IMAGES
of America

LaGrange

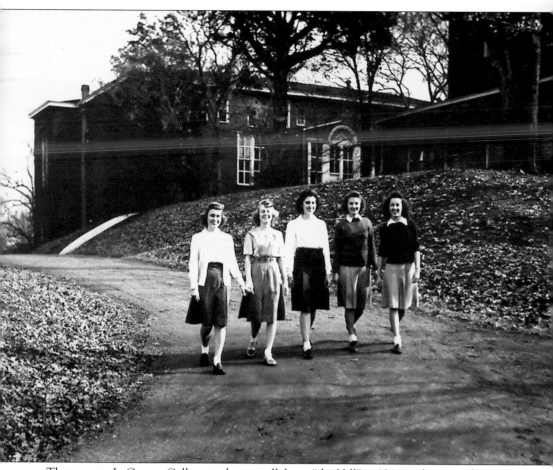

These young LaGrange College students stroll down "the Hill" in 1944 smiling to welcome visitors to the school and community. World War II continued to rage, and the school continued granting degrees only to women. (Pitman Cleaveland Jr. Collection, Troup County Archives.)

ON THE COVER: LaGrange Bottling Works on Vernon Street is prepared to deliver various carbonated beverages to local townspeople in 1914. (Photograph by Snelson Davis.)

IMAGES
of America

LaGrange

Glenda Ralston Major, Forrest Clark Johnson III,
and Kaye Lanning Minchew

ARCADIA
PUBLISHING

Published by Arcadia Publishing
Charleston, South Carolina

Printed in the United States of America

Library of Congress Control Number: 2011921333

For all general information, please contact Arcadia Publishing:
Telephone 843-853-2070
Fax 843-853-0044
E-mail sales@arcadiapublishing.com
For customer service and orders:
Toll-Free 1-888-313-2665

Visit us on the Internet at www.arcadiapublishing.com

We dedicate this book to the many generations of people who have called LaGrange home and to the spirit that has historically made this a great community.

CONTENTS

Acknowledgments 6

Introduction 7

1. What Comes from Beneath 9

2. A Sampler of Early Settlers 15

3. What Colonel LaGrange Saw 25

4. Scenes from Churches and Church Yards 35

5. School Days 47

6. Let Us Entertain You 61

7. All in a Day's Work 79

8. Leisure Life 99

9. Landmarks 115

Index 126

ACKNOWLEDGMENTS

The people of LaGrange and the rich heritage they created have made this book possible. Hundreds of thousands of people who have lived here since 1828 have shaped this history through their everyday lives. The stories they tell and the photographs they make and preserve went into the fabric of this publication. On behalf of the Troup County Historical Society and Troup County Archives, we appreciate the many people who have graciously donated photographs over the years and answered our calls for information.

The ever-growing number of photographs in the collections of the archives provided the basis for this book and also meant hard choices had to be made during the selection process. Major collections and photographers drawn from include Snelson Davis in Nix-Price, Stanley Hutchinson in Ehrenberger, Katherine Hyde Greene, Callaway Educational Association, and LaGrange College. We also used several photographs by Julius Schaub. All images without credit lines are from the collections of the Troup County Archives.

Special thanks are due to several individuals. Jim Biagi was always enthusiastic and gracious in identifying the make and models of automobiles shown in this book. Lee Cathey of Multi-Image Studio and John Lawrence of LaGrange College shared photographs. Alberta McMillion kindly helped the many times we called on her. Staff members at the Troup County Archives assisted with the project, especially George Allen and Randall Allen, who prepared illustrations. As always, we thank our families for their continued support and interest.

—Glenda Major, Clark Johnson, and Kaye Minchew

INTRODUCTION

LaGrange, Georgia, is a city of about 29,000 people located in the heart of West Georgia, in the gently rolling hills of the Piedmont Plateau. The pioneering people came largely from eastern Georgia, the Carolinas, and Virginia, descendants of British and West African cultures. Over time, emigrants from Germany, Eastern Europe, and Lebanon joined them. During the past quarter century, new residents have come from Latin America, Japan, and Korea.

Troup County, named for Georgia governor George Troup, was created in 1826 on land the United States bought from the Creek Nation in 1825. The state chartered LaGrange in December 1828 as the county seat. The name honored the Marquis de Lafayette, who served on the staff of George Washington in the American Revolution. Col. Julius Alford, who traveled across Georgia with Lafayette in 1825, suggested "LaGrange" after Lafayette's home in France, the Chateau de LaGrange.

The Inferior Court selected the site, and one justice, surveyor Samuel Reid, laid out the still-used basic street plan in 1827, before the official chartering. The face of LaGrange has changed over the past 180-plus years, but something remains from every generation. The fertile, well-watered hills and hardwood forests of Troup County attracted planters who accumulated large holdings and quickly refined Troup's frontier. They brought the luxuries of wealth and built manifestations of it: churches, schools, and rambling homes with formal gardens.

LaGrange was soon a hub of commerce, government, culture, and education. Of three antebellum female colleges and one male university, the sole survivor is LaGrange College, founded in 1831 as LaGrange Female Academy. The earliest churches congregated before the town received its charter. By 1860, LaGrange was the capital of Georgia's fourth wealthiest and fifth largest slave holding county. The town boasted over 100 large, mostly Greek Revival homes, each with boxwood and flower gardens. Many landowners lived in town to direct their diverse economic interests.

The people of LaGrange did not favor secession in 1860 but supported Georgia when war came. The war brought refugees, Confederate hospitals, and small battles nearby. The Nancy Hart Woman's Militia formed in 1861 for town defense when a majority of men left for war. The women later served as nurses when LaGrange became a hospital zone. They expected a battle to save their homes in 1865. The invading commander, coincidentally named Oscar Hugh LaGrange, who had not burned whole towns previously, promised to spare the homes in town and thus avoided battle. Prewar diversification meant quicker recovery afterwards.

After 1865, whites helped blacks build schools and churches by donating land, money, and materials. Prominent blacks, such as bridge builder Horace King, settled in LaGrange, where he and his sons dominated construction business until 1900. Two black high schools opened in the 1860s. One was later part of the original public school system in 1903.

Cotton manufacturing reached LaGrange in 1889, and the town had nine textile plants by 1930. Local investment and promoters directed the growth. Mill owners were mostly from the former planter aristocracy. Leading families included Truitt, Callaway, Dallis, and Dunson.

Mill neighborhoods provided houses, schools, churches, every conceivable recreation facility and team, art and music, and medical care for workers and their families. The company that became Callaway Mills institutionalized philanthropy with Callaway Foundation, Inc., and Fuller E. Callaway Foundation, Inc. Both continue supporting public projects. During industrialization, LaGrange organized police, fire, and utility services and public schools. By 1907, three railroads met in LaGrange. The town kept its reputation for beauty, planting thousands of trees annually, which gave rise to its nickname "City of Elms and Roses."

When World War I came, LaGrange people, though opposed to involvement, fully supported the United States. Troup County and LaGrange were recognized as the first in the nation to over-subscribe their quota in every War Bond drive. The LaGrange war organization plans became the model for the nation.

During the Great Depression, all mills worked to keep someone in each family employed. Several New Deal projects changed LaGrange during the 1930s. In World War II, local manufacturers won war production Excellence Awards. LaGrange men and women served all across the globe. Following the war, many LaGrange neighborhoods changed as mill workers left their villages to acquire homes in the suburbs. Textiles continued as the economic base, though in the 1960s, local leaders began seeking diverse industry. A new town slogan, "America's Greatest Little City," captured that spirit. Many companies developed new plants in LaGrange and nearby including Interface, Wall Street Journal, Duracell, Kimberly-Clark, Freudenberg-NOK, Mountville Mills, Wal-Mart Distribution, Sewon America, and a Kia Automotive Plant.

The 1970s brought many changes. A US-constructed dam on the Chattahoochee River brought recreation and other opportunities. Two interstates arrived. LaGrange added a statue of Lafayette to its signature fountain in the main square. A mall joined several shopping centers as the town expanded. Local and international clubs offered opportunities for service at home and abroad. Sister City involvement promoted friendship and understanding with other nations through association with Aso, Japan; Poti, Republic of Georgia; and Craigavon, Northern Ireland.

LaGrange continues to offer advantages not usually found in places of similar size with colleges, art museums, a history museum, historic sites, a ballet company, professional-level choral and theatrical groups, a world-class symphony, and major performance venues. Special events fill the calendar, from storytelling and other festivals to parades at Christmas, the Fourth of July, and Martin Luther King Day. Modern recreation facilities serve every sport imaginable and attract regional and state-wide tournaments. Several radio and television stations, newspapers, and magazines serve the public. West Georgia Health and many clinics offer the finest medical care. Specialties include cancer, heart, geriatrics, orthopedics, hospice, and primary care.

LaGrange recently has spent millions improving downtown, with new structures, sidewalks, and businesses, and expanding its two colleges. Organizations such as DASH (Dependable, Affordable, Sustainable Housing) have revitalized other sections. In 2001, LaGrange received Intelligent City of the Year and Government Technology Leadership Awards. These confirmed another town motto, "LaGrange, Georgia: Smart Move." In 2010, America's Promise Alliance included LaGrange in the 100 Best Communities for Young People.

It is hoped this book will entertain and enlighten LaGrange residents new and old and people living far away who share an interest in the city. The captions bring history to life while calling up other stories, promoting an interest in history, and encouraging people to bring additional photographs and documents to the Troup County Archives for preservation.

One

WHAT COMES
FROM BENEATH

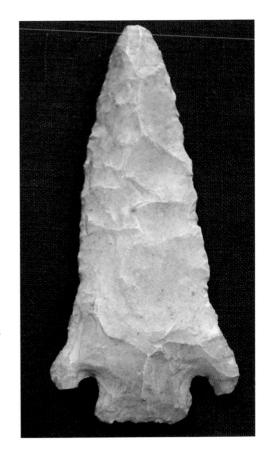

Some of what is known about a place is learned from archaeology and what comes from beneath the surface. This spearhead tells about the Indians who once lived here. The Creeks were the last Indian tribe to inhabit the area and lived here from roughly 1500 to 1826. Before the Creeks, the Woodland and the Mississippian Indians lived here. The latter group is known to have built mounds. (Courtesy of Clark Johnson.)

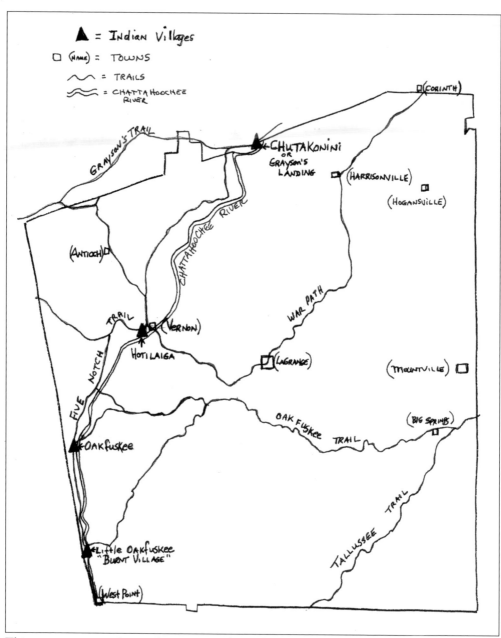

= Indian Villages

☐ (Name) = Towns

⌒⌒ = Trails

≈≈ = Chattahoochee River

Corinth

Chutakonini or Grayson's Landing

Grayson's Trail

Chattahoochee River

Harrisonville

Hogansville

(Antioch)

War Path

(Vernon)

Hoti Laiga

Trail

Five Notch

(LaGrange)

(Mountville)

Oak Fuskee Trail

Big Springs

Oakfuskee

Tallussee Trail

Little Oakfuskee "Burnt Village"

(West Point)

This map attempts to locate the various Indian villages and trails that ran through what is now Troup County when the United States purchased the lands in 1825. Early settlers used these paths to gain access to the area. The site chosen for the county seat, called LaGrange, was located in the geographic center of Troup and along the "Old War Path." The Creeks used the war path when launching attacks against the Cherokees to the north or English and American settlers to the east. Most of these trails were later widened into roads. Together with other pioneer roads, these routes formed a transportation network, much of which is still used today. Known Indian villages are marked with triangles. Cities and communities of Troup County are shown in parentheses. (Map by Clark Johnson.)

10

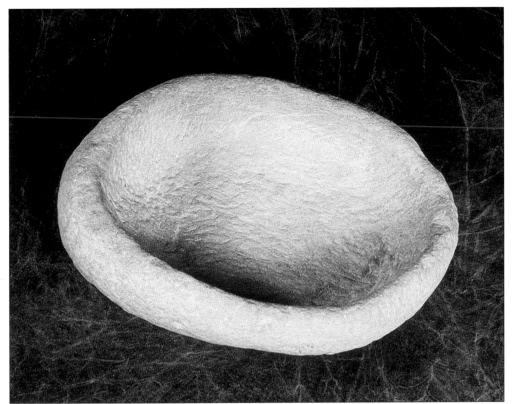

Though extremely rare today, grinding bowls such as this one would have been common household items used by Indian women in preparing meals. They served as the original food processors. This bowl was discovered in nearby Harris County on land owned by Howard "Bo" Callaway and is on display at Legacy Museum on Main. (Photograph by Lee Cathey.)

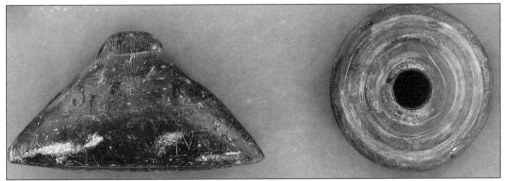

William Orrie Tuggle of LaGrange donated these objects to the Smithsonian in Washington, DC, in 1878. When he died in 1885, he left journals detailing social and political life in the capital, plus stories and folktales collected while he represented the Creek and Yuchi Indians in their legal claims against the US government. The University of Georgia Press published his diaries, *Shem, Ham, and Japheth.* These Indian artifacts probably served practical purposes.

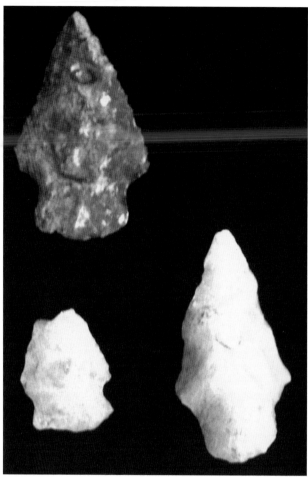

Probably the most common Indian items still found in LaGrange and Troup County are arrowheads and pottery shards. They could come from several different time periods. Experts can usually date them from their style and detailing. The majority found today are from the Creek Indians, who began arriving from the west about 1500. Theirs was the last wave of Indian settlement in the area. In 1972, archeologists from the University of Georgia received a grant from Callaway Foundation, Inc., to conduct several digs prior to the impoundment of West Point Lake. In the 1966 photograph below, Dr. Harold Hurscher and Ms. Newton examine the excavations in this grid laid out to study Burnt Village. (Left, arrowheads on loan from UGA archeology department; below, photograph by Katherine Hyde Greene.)

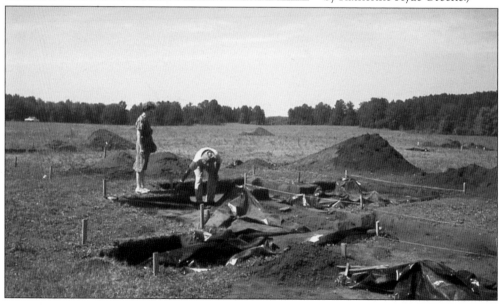

This lead tablet is thought by some to be a record of animal sales by a Sumerian businessman. It was unearthed by Nina Hearn at her West Point Road home in 1967. Cuneiform experts concluded this is the oldest writing ever found in America, dating to about 2050 BC! Others question the likelihood that a Sumerian came up the Chattahoochee River and reject the tablet's authenticity. It remains a Troup County mystery and is on display at Legacy Museum. (On loan from LaGrange College.)

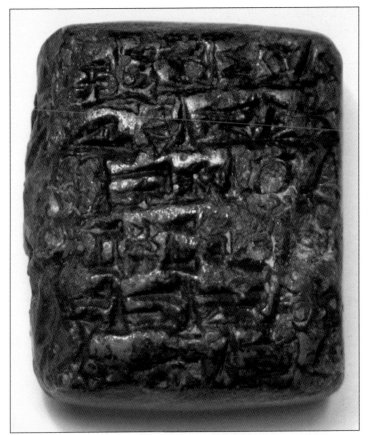

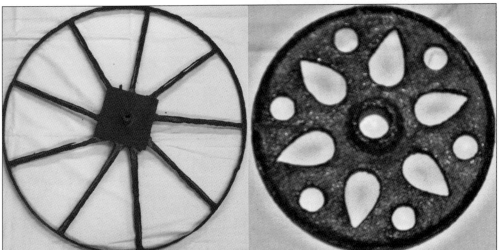

On the Chattahoochee River, flat boats carried early traders and goods between Standing Peachtree near Atlanta and Grayson's Landing, north of LaGrange. Steamboats traveled limited stretches of the river above the fall line north of Columbus, where the Piedmont meets the Coastal Plain. River traffic continued into the late 19th century. Members of the West Georgia Underwater Archeological Society recovered these 1880s boat wheels from the Chattahoochee near West Point.

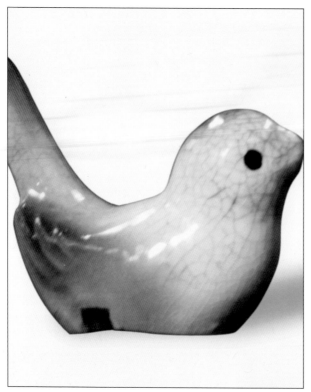

An archeological site was uncovered in the fall of 2007 as grading work began for the Lewis Library at LaGrange College. Construction halted briefly while a quickly assembled corps of students and faculty dug for artifacts. Once digging was completed, volunteers began cleaning, organizing, and describing over 500 relics that are now part of the college archives. Students and faculty members researched the artifacts at the Troup County Archives. The objects came from what is believed to be the school's old burn pit and trash dump, located outside the school's former kitchen, which sat behind Smith Hall. The elegant glazed porcelain bird survived decades in its underground nest. The bird might have once been a student's treasured knickknack. Library staff members Jennifer Wiggins, left, and Charlene Baxter are digging for artifacts.

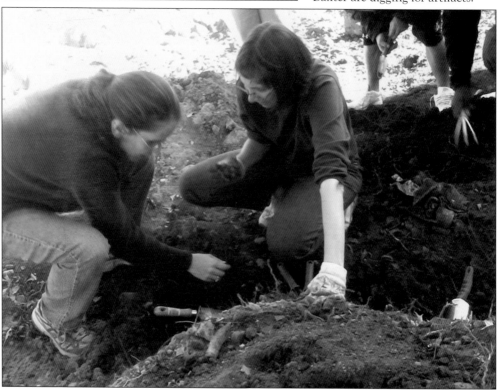

Two

A Sampler of Early Settlers

Many plantation owners chose to live in LaGrange rather than in the country. These men and their wives served as leaders in all aspects of life: social, economic, political, and religious. Growing up, their daughters acquired skills by working on samplers similar to Clare Marchman's piece from the 1910s. They learned decorative arts, the skill of sewing, and reading, writing, and numbers as they stitched. (Courtesy of Julia Traylor Dyar.)

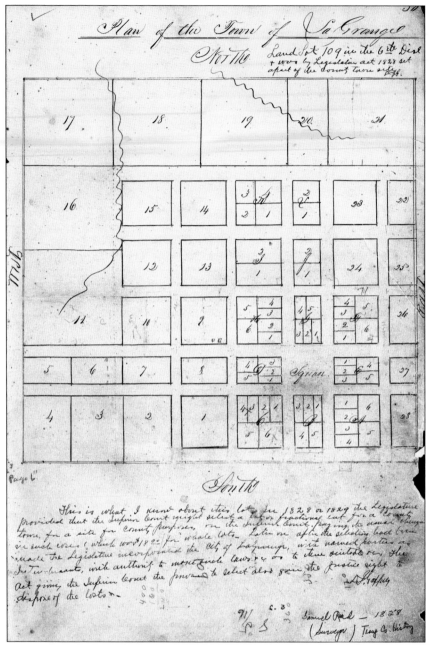

Georgia surveyors laid out newly acquired lands in 1826 as the Indians moved west. The following year, a statewide lottery distributed the numbered lots. Every family living in the state for at least three years had a chance to win. In 1827, land lot 109 of the sixth district was selected the county seat of Troup County. At a community meeting, Col. Julius C. Alford suggested that the town be named LaGrange to honor the Marquis de Lafayette. Alford had accompanied Lafayette on part of his 1825 tour of Georgia and allegedly heard him remark on the similarity of this area and his home in France, the Chateau de LaGrange. The street plan was drawn by Samuel Reid, county surveyor and justice of the Inferior Court, assisted by William Moreland and Henry West. The basic plan remains in use today. (Inferior Court Minutes, Troup County.)

Among the earliest settlers in LaGrange who left a lasting legacy are Blount and Sarah Ferrell. They married here in 1835. After six years in Marianna, Florida, they returned and built a home next to her parents' home on Vernon Street. For 62 years, Sarah developed Ferrell Gardens, expanding a small boxwood garden started by her mother in 1832. The gardens are now part of Hills and Dales Estate. (Dill and Maier, Photographers of Atlanta.)

The family of Capt. Shirley Sledge Jr. had photographs made of him on his deathbed in 1883 because in life he would never allow his picture to be taken. He served in both the Creek Indian War of 1836 and the Civil War. His wife, Jane Curtright, was best friends with Sarah Ferrell. They often ordered exotic plants together for their formal gardens. Sledge Gardens stood near Big Springs community.

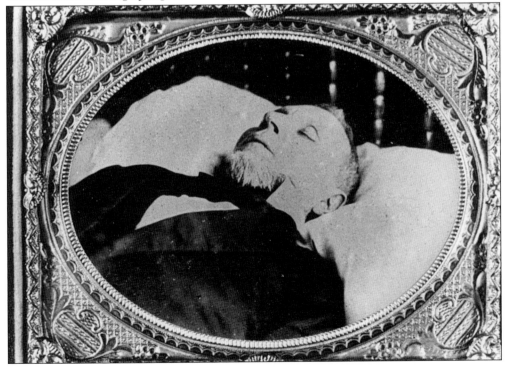

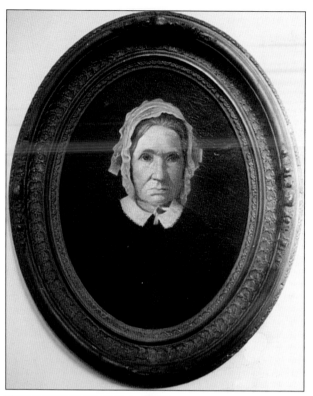

James Tomlinson painted this portrait of Mary Dortch Pitman Cox in 1870, seventeen years after she died. He used a photograph taken about 1850 to create her likeness in oil. Tomlinson, also a noted photographer, did many such portraits for early LaGrange families. Traveling photographers were known to have been in LaGrange as early as the 1840s, soon after the invention of photography.

Many of the original streets in LaGrange now bear family names of early settlers. The city council named the majority of the streets between 1870 and 1893. This corner honors two early LaGrange physicians. Dr. Andrews Battle died in LaGrange in 1842 at age 48. Dr. Robert A.T. Ridley, known affectionately as R.A.T. Ridley, practiced here for many years. He was the first of three generations of Ridley physicians in LaGrange.

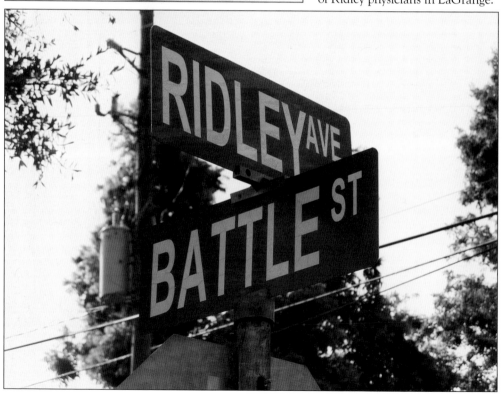

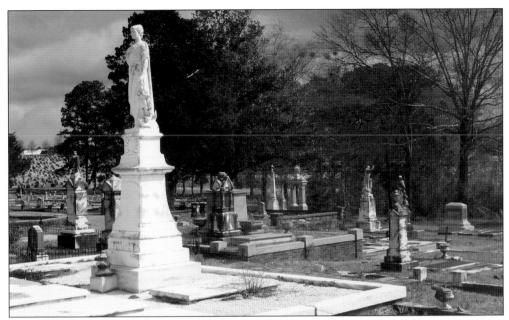

One of the finest tombstones found in the oldest cemetery of LaGrange is that of Elizabeth Parks Merritt. Older cousins James G. and Mary Hall Truitt, who had no children, raised her. She graduated from LaGrange Female College in 1892. She died in 1896 at age 24 of a relapse of measles. The grief-stricken Truitts commissioned this sculpture for her grave, which was carved in Italy using a photograph of her.

When 21-year-old Abner Turner died on March 26, 1830, he had the dubious honor of being the first person buried in the city's newly established cemetery. His will, in Will Book A, page 1, was the first recorded in Troup County. Hill View cemetery was started on the public lot originally set aside for Troup County Academy. Though nearly full, Hill View plus adjoining cemeteries Hill View Annex and Shawdowlawn continue to serve city residents.

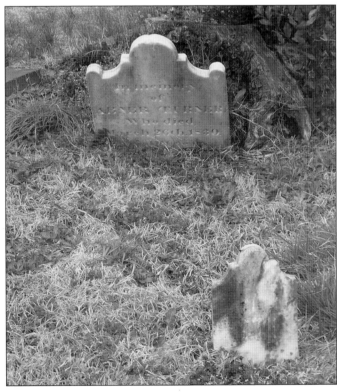

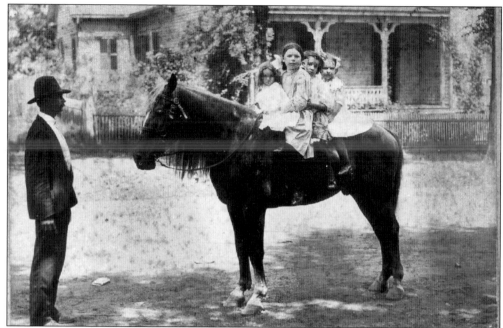

These girls on their horse, Elmo, are fourth-generation natives of Troup County. Their father, Philip Hunter Greene II, stands nearby in this c. 1908 photo. His grandfather, Philip Greene, came to LaGrange in the 1820s. He built two family homes that still stand. One on Greenville Street is now Thyme Away Bed and Breakfast. He later built the Oaks on Vernon Street in 1845. The girls are, from left to right, Louise, Minnie, Pauline, and Maedelle.

Nancy Tarver and her son, John Colquitt, antebellum and Confederate postmaster, lived on Church Street until about 1865. Dr. Jesse Boring, the first minister to preach in LaGrange, married Gen. Thomas Evans to Rhoda Swanson here in 1830. An 1889 article states that Boring arrived late due to a flooding Chattahoochee River. His torn coat, which he continued to wear, was mended as he performed the ceremony. Albert Lehmann and family lived here from 1889 to 1961.

This beautiful stained-glass window, one of the largest at Warren Temple Methodist Church, is dedicated to the Harrison family. James W. Harrison was patriarch of the family. A freed man in the 1850s, he enjoyed a successful career as a LaGrange barber. After the Civil War, his various business enterprises helped him become one of the most prominent black landowners in the county. Family members continued to be active in local affairs into the 20th century.

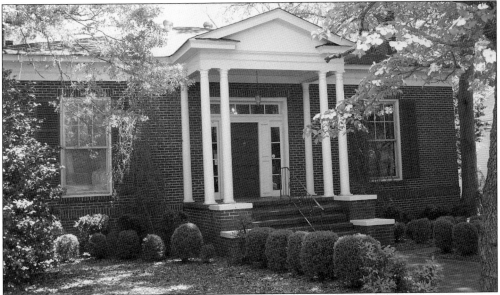

The Herring house stands as the last surviving 1830s brick home in LaGrange. Masonry houses were rare in the early decades of settlement. Builder James Herring served as postmaster and operated a tavern on the square where First Baptist now stands. His daughter-in-law ran a successful mail-order nursery business from the house in the late 1800s. This was also the childhood home of beloved educator Berta Weathersbee. The Church Street facade probably looks much the same as when constructed.

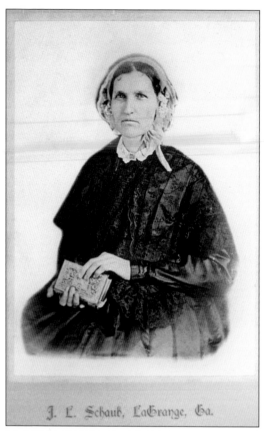

J. L. Schaub, LaGrange, Ga.

Barbara Howell Curtright moved to Troup County from Greene County about 1830 with her husband Samuel and her parents. Her grandfather, Daniel Wagnon, a Revolutionary War veteran, came with them. The Curtrights lived in LaGrange, the center of their diversified economic interests, including a bank, hotel, steam planing mill, railroad, and large plantation. This diversity was typical of the planter class in Troup County. Three of their five sons, who served in the Confederacy, died in battle.

Architect and builder Collin Rogers built the Magnolias for Joseph McFarland in the mid-1830s. In 1889, Lewis Render bought the house, which was home to four generations of his family. The front parlor, shown here in the 1970s, features design elements from several eras, including antebellum furniture, Victorian wallpaper, and newer draperies. Originally located on Hines Street in LaGrange, the house was moved to Coweta County.

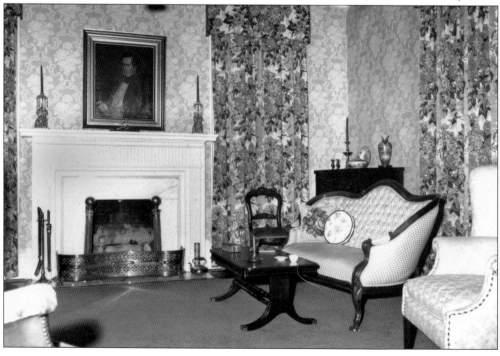

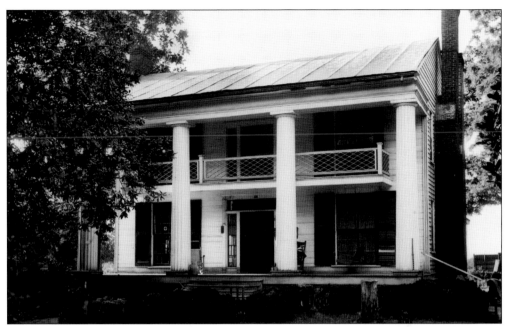

Thomas Bristow Greenwood built this house on his two-acre town lot in 1840. The house faced Broad Street on the corner of Greenwood Street, which was named for him. Three generations of his family lived here before William Huntley acquired the home. The house stood until the mid-1950s. A bank built here three decades later has preserved the magnolias that once graced the front of the house. (Courtesy of the Library of Congress.)

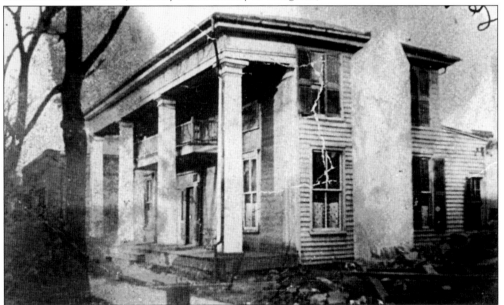

John Gibson Whitfield bought this 1830s home facing Ridley Avenue from his father-in-law, Benjamin Bolton Amoss, in 1859. The house featured square columns and Greek Revival doors and windows. Whitfield and Amoss operated a dry goods store in LaGrange that sold Valentine cards as early as 1879. The house stood until the early 20th century. Whitfield Crossing, located between LaGrange and Hogansville, is named for John's father, Horatio.

$250.00. By the 25th Day of December next we Either of us promise to pay Mary L. Brown or Bearer the sum of Two hundred and fifty doll for the hire of the Boy William and also to furnish him with one winter suit and two summ suits of clothes one Blanket. one hat. and one pair of shoes.

This January 4th 1854. Carlton. *[signature]*

First families of Troup County included as many blacks as whites, but finding documentation for individual slaves is difficult. Their contributions to the economy were extensive, furnishing much labor and craftsmanship. They provided some of the carpentry and masonry skills needed for houses, buildings, roads, bridges, and more. Slaves were a substantial basis for the area's vast wealth. In return for their work, slaves received housing, food, medical care, clothing, tools of their trade, and training. Some learned to read and write. Hiring out talented slaves produced income for owners. In typical agreements like this one, the renter had to furnish items to the slave, such as blankets, suits of clothes, and shoes. (Troup County Superior Court Records.)

Three

WHAT COLONEL LAGRANGE SAW

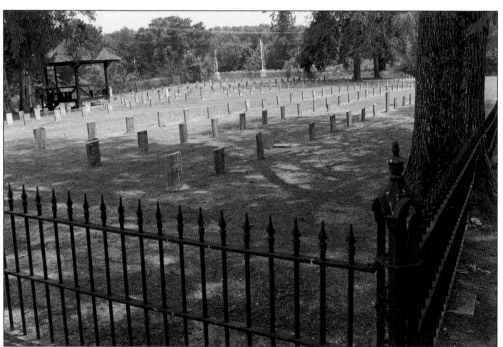

A lasting memorial in LaGrange of the Civil War is Stonewall Jackson Cemetery. Soldiers wounded during the 1864 Atlanta Campaign were transported by train to local Confederate hospitals. Men from all Confederate states are buried at the Miller Street cemetery. Citizens of LaGrange first placed wooden boards on the graves in 1884; these were replaced with headstones in 1912. The Sons of Confederate Veterans are installing new government markers. (Stanley Hutchinson, photographer.)

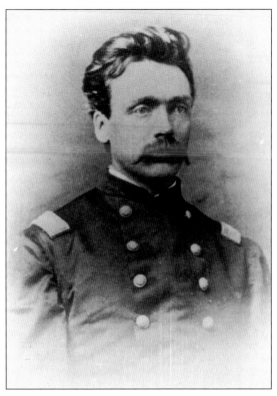

Col. Oscar Hugh LaGrange of Wisconsin led a detachment of the US Army into Troup County on Easter Sunday, April 16, 1865. His commander, Gen. J.H. Wilson, dispatched him from Opelika to capture and destroy the bridges at West Point. Fort Tyler, built to defend the railroad bridge, fell to the Union troops in the Battle of West Point. The following day, they marched toward the county seat, which coincidentally bore the same name as their leader. People in LaGrange supported the Confederacy, though most originally opposed secession in 1861. At least eight companies of men left Troup County for the war, where at least 413 died. The map shows the route Colonel LaGrange traveled through the city. (Left, courtesy of the US Army Military History Institute; below, courtesy of Clark Johnson.)

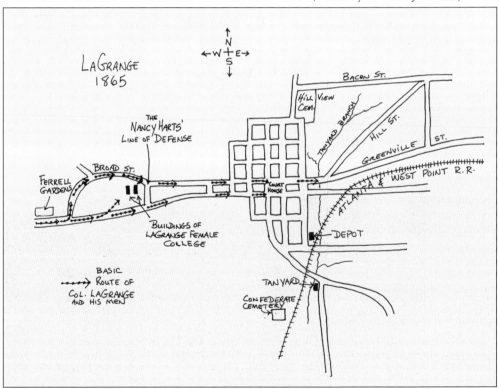

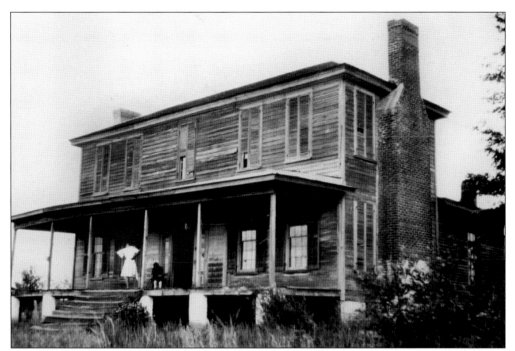

As Union soldiers marched from West Point to LaGrange, they traveled what is basically today US Highway 29. Their route took them between the Traylor home and the family cemetery. George Hamilton Traylor built the house about 1834. Occasionally, beautiful antebellum homes fell into disrepair when the family moved into town. When the photograph above was made in the mid-1930s, farm laborers lived in the house. The family sold the house in 1964 but continues to own and maintain the cemetery. New owners have since restored the house. They altered the front porch to give it a more classical appearance, perhaps more in keeping with its original design. Pecan trees line the sweeping semicircular drive. (Below, photograph by Katherine Hyde Greene.)

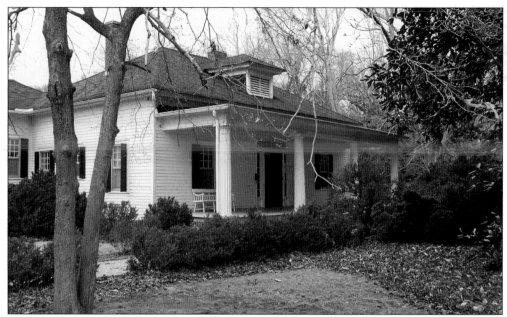

As Colonel LaGrange and his men marched toward the city of LaGrange, they passed several houses at what was then the outskirts of town, including the Mickleberry Ferrell home. Ferrell's sons-in-law, Capt. Blount Ferrell and Col. James Fannin, were among those captured at Fort Tyler who rode with the Union officers as prisoners of war. During the war, captors often forced POW officers to ride with their own officers to discourage snipers.

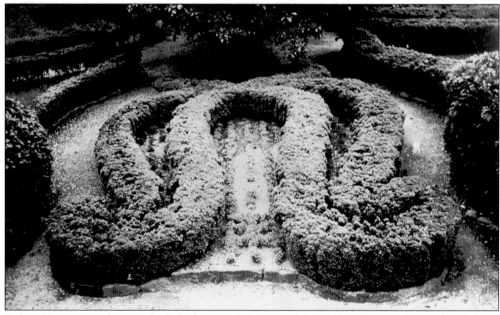

Colonel LaGrange then reached the home of Blount and Sarah Ferrell, next door to her father's home. As Union troops rode their horses toward the house, they encountered the spectacular beauty of Ferrell Gardens. The men carelessly trampled the shrubbery and flowers until Colonel LaGrange saw the boxwood motto "God is Love" and ordered them back to the road. This giant harp is one of many religious symbols in the gardens.

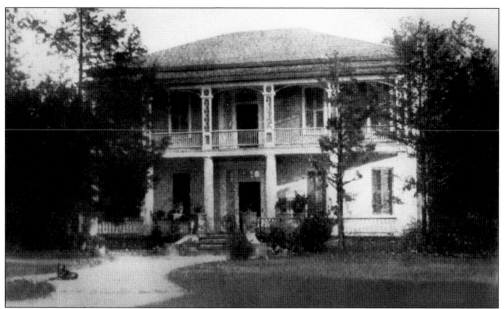

Union troops reformed their line outside Ferrell Gardens in front of these houses. New Orleans refugees Joseph and Belle Harris lived in the house, which Benjamin Cameron built in the 1850s. The porch has since been altered. The head of the army stood in front of the Oaks, home of Philip and Mildred Sanford Greene, shown below. Built in 1845, the home is a grand Greek Revival structure. Because her son Eugenius was at the Battle of West Point, Mildred Greene sent her daughter Mary to acquire news from the officers. Colonel LaGrange paroled her son overnight. In exchange, Mary gave the commander a cup of what passed for coffee. As they rested, the colonel sent scouts to see what lay ahead in town. Pat and Gail Hunnicutt are preserving the house above, and the Stan Hall family restored the Oaks, below.

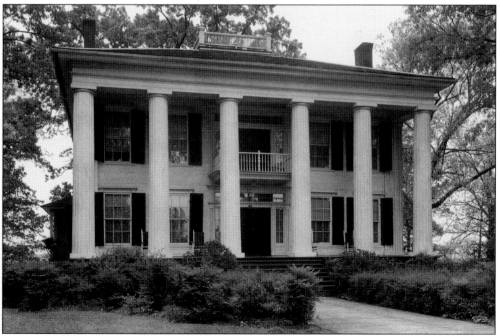

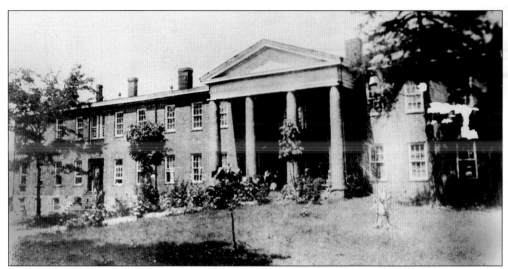

Officers and some men traveled toward Broad Street while the rest advanced along Vernon Street. A group secured the two buildings of LaGrange College. One, now called Smith Hall, had been completed during the war and was used as a Confederate hospital. The other building stood in ruins from an 1860 fire. The war hindered reconstruction and delayed its reopening until 1877. The new building, later known as Dobbs Hall, burned in 1970.

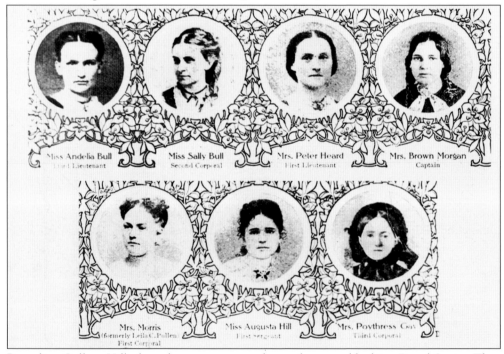

Miss Andelia Bull
Third Lieutenant

Miss Sally Bull
Second Corporal

Mrs. Peter Heard
First Lieutenant

Mrs. Brown Morgan
Captain

Mrs. Morris
(formerly Leila C. Pullen)
First Corporal

Miss Augusta Hill
First Sergeant

Mrs. Poythress Coy
Third Corporal

Rounding College Hill, the column encountered armed women blocking Broad Street. They were a female militia unit formed in 1861 for home defense and named for Nancy Hart, a Georgia heroine of the American Revolution. Remembering Sherman's March to the Sea, they were determined to save their homes. Colonel LaGrange, not as destructive as Sherman, promised to spare houses in exchange for their weapons. Later, the Nancies furnished supper for Yankee officers and their prisoners.

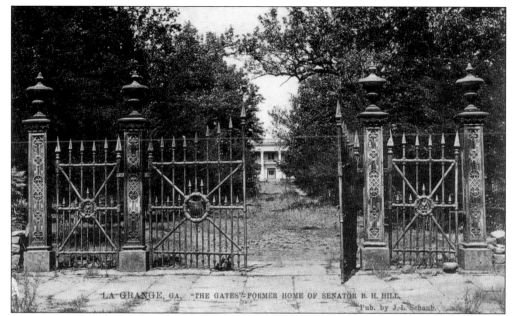

Colonel LaGrange soon reached the gates of Bellevue, home of Confederate senator Benjamin Harvey Hill. The gates had been ordered from a Philadelphia foundry in the same pattern as those at the White House in Washington, DC. They were purchased from and erected by noted ironsmith Louis Hartman of Philadelphia in 1856. The remnants of these gates are at LaGrange College, a gift of Alice Boykin McLendon, whose father-in-law bought the place from Hill in 1867.

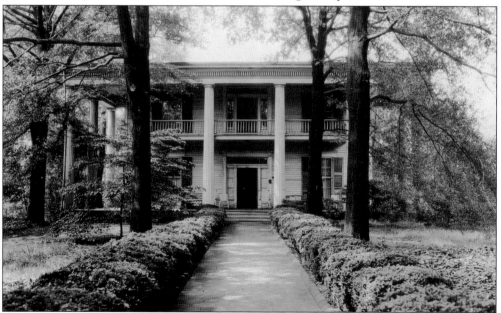

Two blocks west of the square on Broad Street, the Union army saw the home where the Nancy Harts gathered that morning to march out and meet the enemy. Two of the Nancies, Mary and Margaret Alford, who had married Heard brothers, lived here. Their sister-in-law, Martha Heard Beall, planted these rows of boxwood in the late fall of 1861 and shortly afterwards fell ill and died of pneumonia.

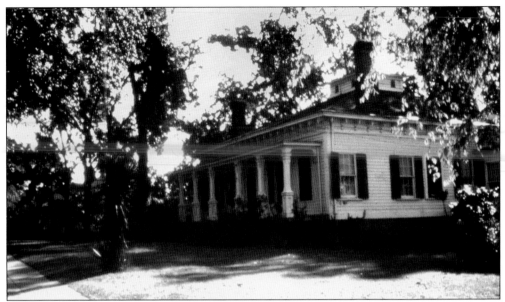

Continuing toward the square, the Union army passed a driveway that would later become South Lewis Street and saw this Italianate cottage, built by Nicholas Lewis in the 1840s. At the time, former US congressman Philip Phillips owned the home. His wife, Eugenia Levy, imprisoned after the fall of New Orleans, had earlier been suspected of being a Confederate spy in Washington, DC. They were among the war refugees in LaGrange.

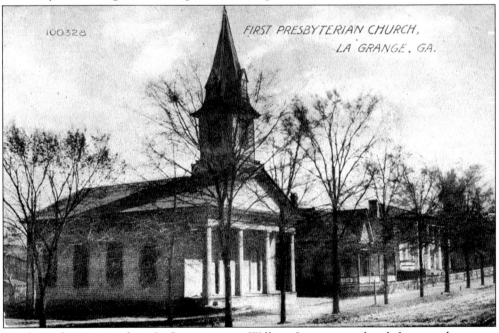

Reaching the square, where LaGrange mayor William Long surrendered the city, the troops fanned out to side streets. One block north was the 1844 Presbyterian church. This was one of many buildings commandeered for use as Confederate hospitals. The Baptists, whose basement was also used as a hospital, shared their sanctuary with the Presbyterians. The house to the far right was the home of Dr. George B. and Alberta Heard.

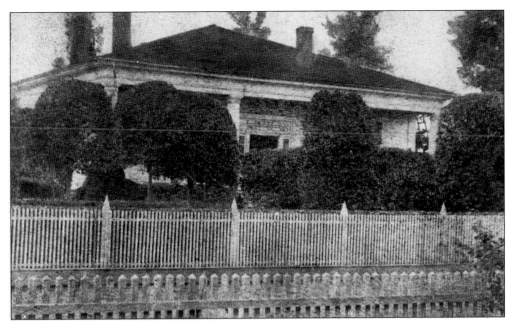

Several grand houses lined the two main streets leaving town toward the east. This Greek Revival cottage sat on Newnan Road, now called Hill Street. Built about 1849 by Sylvanus Bates, this had been home to John L. Stephens, brother of Confederate vice president Alexander Stephens. Owner William Dansby was captured at West Point in 1865. The picket fences were typical of the era. Dan and Jo Stark preserved this as Hill Street House.

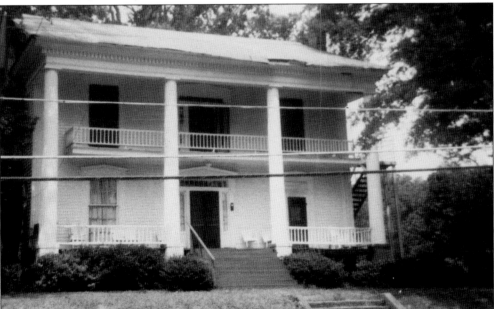

The home of Capt. Francis Frost, also captured at West Point, stood on Greenville Street. Gen. Robert C. Tyler convalesced here after suffering leg wounds at the Battle of Missionary Ridge. The Union army camped in town that night, and some looting occurred. The next day, Colonel LaGrange ordered all war-support facilities destroyed, including the depot, railroad tracks, telegraph line, tannery, and tinworks. They spared the furniture factory, which made only coffins.

This 1830s home of the Nathan Van Boddie family stood elegantly between LaGrange and Mountville as Union soldiers passed by on April 18, 1865. Anxious family members and servants probably bolted the door and watched as the Union column passed by. Like others, the Boddies had hidden the silver, salt, and other valuables. Union soldiers burned their cotton and took most of their food. Aley Smith Boddie, who had been a Nancy Hart, believed for the rest of her life that the home was spared when a Union officer felt compassion for her sick infant son Robert, who died a few months later. The soldiers marched on to Macon, where they learned of the surrender of Confederate general Robert E. Lee. The men captured at West Point were paroled. (Photograph by Katherine Hyde Greene.)

Four

SCENES FROM CHURCHES AND CHURCH YARDS

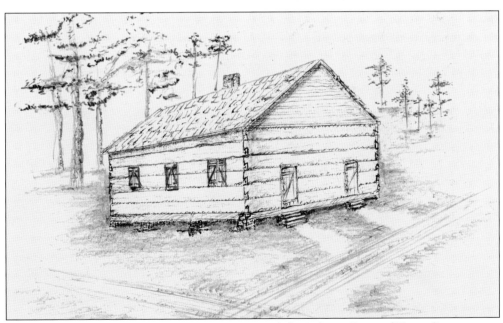

When establishing the county seat, Georgia required the Inferior Court of Troup County to set aside certain lots for schools and churches. One lot on Broad Street went to the Methodists, where they built even before the county purchased the land. The court gave another lot on Bull Street to the Baptists and Presbyterians to use jointly. This artist's rendering depicts how those early hewn-log meetinghouses might have looked. (Courtesy of Randall Allen.)

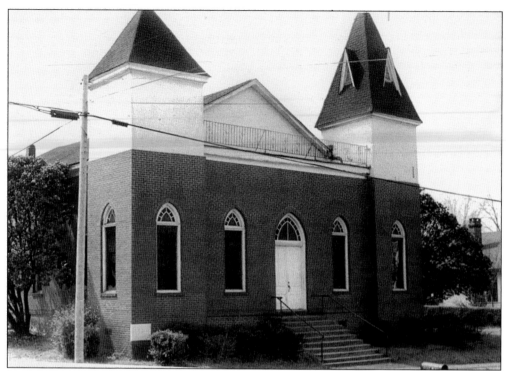

In 1868, many of the black members of First Baptist Church chose to build their first meetinghouse on lands donated by Judge Blount Ferrell. They constructed this large Gothic sanctuary on Fannin Street in 1898. They later added brick veneer and stained-glass windows. In 1980, having outgrown the old sanctuary, they removed the beautiful old windows, as indicated in the photograph, and featured them in their new church home.

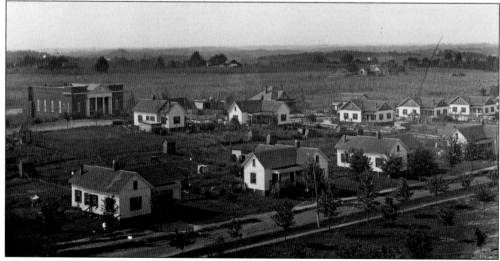

When Dunson Mill opened in 1911, owners provided churches, houses, and recreation facilities. All the early mills in LaGrange followed this pattern. Shared by Baptists and Methodists, the first church in Dunson Village was a union church, the brick building in the upper left. After the church burned in 1927, each denomination built its own sanctuary on Barnard Avenue. The LaGrange Board of Education built Dunson School, now DASH apartments, between them in 1937.

Local churches often reach beyond their doors and provide services and opportunities for the community. The connection between scouting and LaGrange churches began in the earliest years of scouting, the 1910s. These scouts from Troop 72, sponsored by Unity Baptist Church, learned to tie knots. These boys represent three levels of scouting: Cub Scouts on left, Explorers in the center, and Boy Scouts on the right. Area churches continue to support many other youth programs, including Camp Viola.

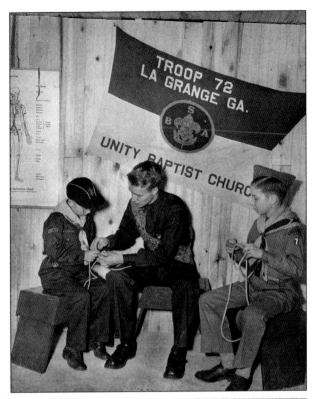

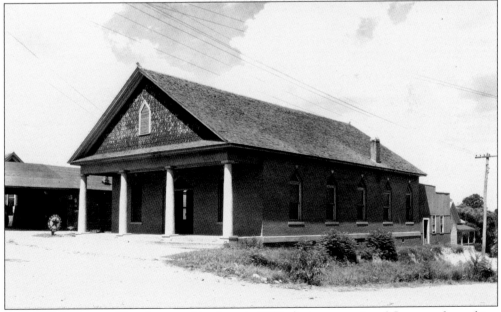

When Unity Baptist Church opened its doors in 1903, the congregation did not need a parking lot, since members lived close by. Located on the corner of South Greenwood and Miller Streets, Unity Baptist used this building until 1975, when it built a larger sanctuary just to the north. This corner became a parking lot. Bobby Robinson served as the minister for three decades before retiring in 2003.

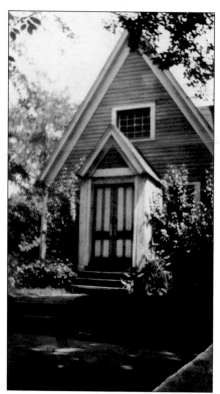

Congregation Beth El has held services here since 1945, having organized in LaGrange three years earlier. The founding members included several prominent merchants whose families were Russian emigrants. Constructed in 1892 on the corner of Church and Battle Streets by Saint Mark's Episcopal Church, the building has a unique ecumenical history. This is one of the rare Jewish synagogues in Georgia to call a former Christian church home. Beth El shared it for five years while Saint Mark's built a new sanctuary nearby. First Baptist also used the building for Sunday school during a renovation at their church. While preserving the structure of the building, the Jewish congregation has added stained-glass windows and elaborately carved doors, as shown below. The doors feature scrolls of the Old Testament.

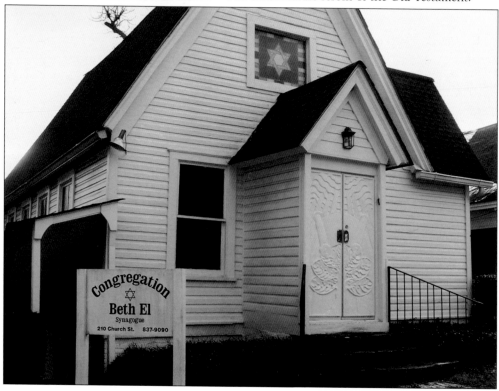

Southwest LaGrange Baptist Church celebrated its 100th anniversary in 2010. The congregation has called this building home since its construction in 1920. Located in the Hillside and Elm City neighborhoods, the church sits at the five-corner intersection that was also home to Trinity Methodist and the original Southwest LaGrange School. With its brick veneer and Ionic capitals on the columns, the architecture is classic Greek Temple style.

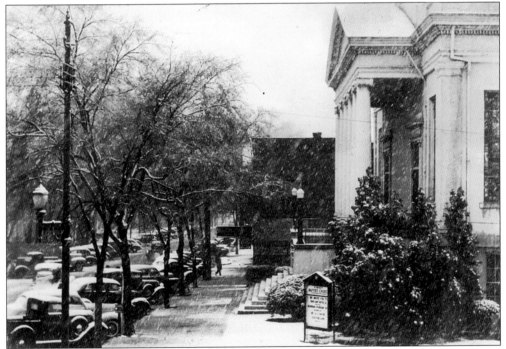

In what could have been a classic Currier and Ives Christmas scene, this photograph captures snow as it fell on the old elm trees and cars at First Baptist Church in January 1940. The two-story building beyond the church sat on land that is now a park between the First Baptist and First Presbyterian Churches. Snow in the South has long been an occasion to pull out the camera.

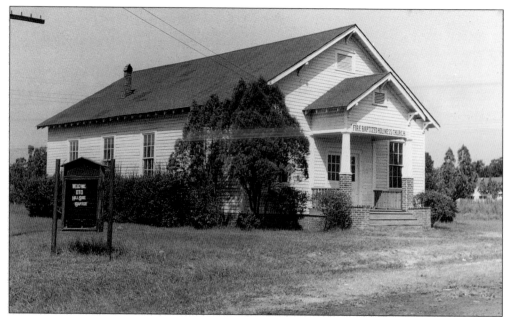

The Callaway group of mills constructed several church buildings throughout its villages. It let its employees decide which denominations they wanted. This church on Jackson Street in the Hillside area thus became home to the Pentecostal Fire Baptized Holiness in the 1930s. Throughout its history, LaGrange has always welcomed new churches. The Church of Jesus of the Apostolic Faith now calls the bricked-over structure home.

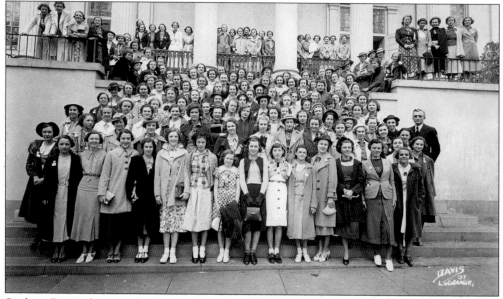

Snelson Davis photographed representatives of the state convention of the Tri-Y Club at First Baptist Church in 1937. LaGrange High hosted the group, which was affiliated with the YWCA. Davis also captured the fashions of the Depression years of the mid-1930s. Several LaGrange women enjoyed recalling the event over 70 years later. The church had several different facades through the years, including this one, which dated from 1922, when the church went from four to six columns.

Many of life's events revolve around churches, including weddings, receptions, confirmations, christenings, and funerals. In November 1944, Horace Richter and Dorothy Pope married in the Ida Cason Callaway Chapel at First Baptist. Since this celebration took place in the midst of World War II, the groom wore his Army uniform, a common wartime occurrence. The Richters lived the rest of their lives in LaGrange, where he served as an attorney for over four decades.

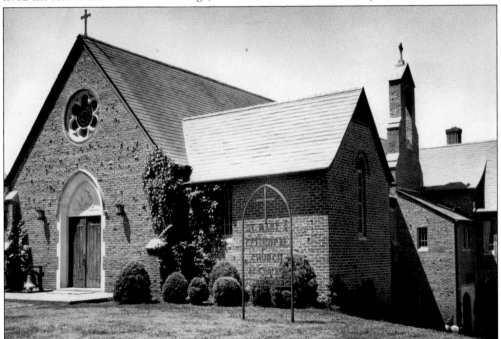

After having organized in LaGrange in 1861, Saint Mark's Episcopal Church opened the doors to its new sanctuary on North Greenwood Street on January 1, 1950. The building featured a bell cote, seen in the upper right, which was removed when the congregation added its large parish hall, offices, and Sunday school room. In 2007, it erected an outdoor bell stand. It rings the bell before and after services.

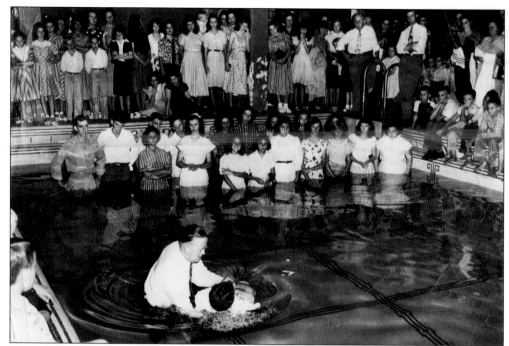

Most Christian churches celebrate the ritual of baptism in one way or another. This group from Saint John Methodist Church gathered at the indoor pool of Calumet Community Center in 1948 to witness the baptism of 19 young people. Rev. J.V. Speer brought 81 new members into the church, although he was only in LaGrange for seven months. Methodists are known more for infant baptisms but allow older converts to choose immersion.

LaGrange Church of God in Christ organized in 1970 on Colquitt Street as a branch of the Holiness Church. A minister and five women formed the first congregation. Like many small churches spread throughout LaGrange, it supports its ministries with annual singings, yard sales, and bake sales. It often joins with other churches in the community. As the sign indicates, the church holds Bible study on Tuesday and "Joy Night" every Friday.

Broad Street Church of Christ built its sanctuary in 1965–1966, replacing the home of Joseph and Mamie Dunson. The church incorporated several architectural details from the old home, including a beautifully carved staircase, doors, walnut wainscoting, and this stained-glass window. Mamie Dunson moved the fountain from her childhood home on Hill Street to her new home during its construction in 1905. The stained-glass window, originally in the Dunson home library, now graces the 2008 church addition.

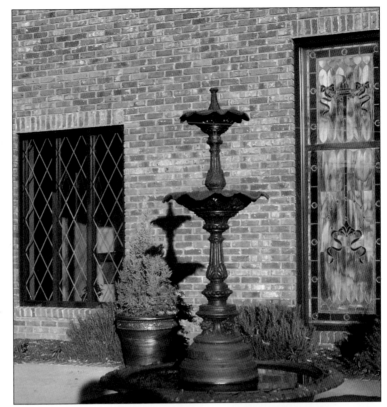

These kindergarten children gathered in front of First Presbyterian Church in 1946. Historically in LaGrange, people from different churches supported each other's programs. Often family members attended Scouts, kindergarten, vacation Bible school, and activities at churches other than their own. The Presbyterians moved into this building in 1922 from their earlier home on Church Street but had to undertake a major renovation in April 1951, when a fire gutted their sanctuary.

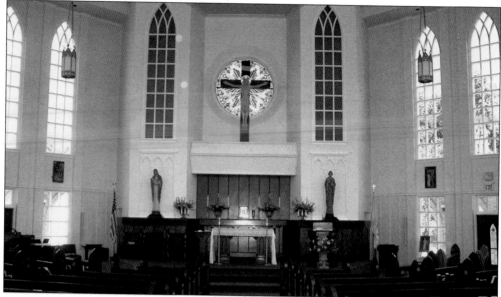

Saint Peter's Catholic Church organized in 1936. This was the first Catholic church in the county, though there had been Catholic residents here since the early days. Construction on this sanctuary began in 1986 on the former site of LaGrange Cotton Mills, last known as Calumet. The octagonal sanctuary features large Gothic windows and a rose window of stained glass above the altar. The life-sized, hand-carved crucifix, installed in 1992, was dedicated in memory of Raymond Jabaley Sr.

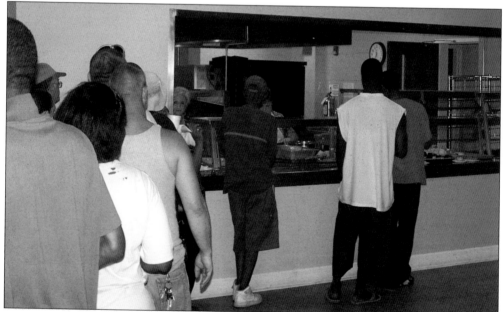

LaGrange churches serve about a thousand free lunches each week as a Christian outreach ministry. The program began in April 1988, when First Methodist Church opened its soup kitchen two days a week. That fall, Saint Mark's Episcopal joined in, and the following year, First Baptist and First Presbyterian began to participate. Many churches, along with the Troup County Senior Center, also provide Meals on Wheels to homebound seniors.

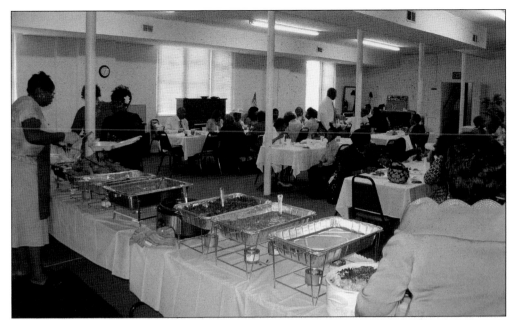

Church dinners and socials enhance fellowship among congregations. Many special occasions, such as annual homecomings, involve food. Members and friends of Warren Temple Methodist Church joined together in their fellowship hall for this meal in 2010. Some churches gather weekly for meals, while others only have covered dish dinners annually. Homecomings, along with Christmas and Easter, draw some of the largest crowds during the year. (Courtesy of Alberta McMillion.)

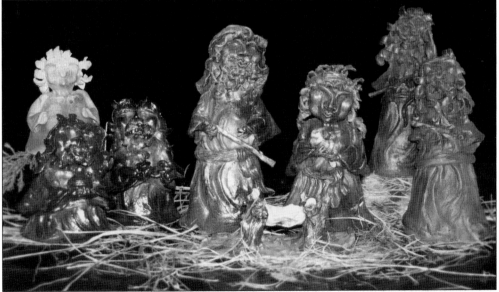

Local artist Donna Kirkendall created this unusual interpretation of a crèche in 2009. Broad Street Church of Christ featured the crèche when it joined other LaGrange churches in publicly displaying nativity scenes. What is now an annual event began in 2002 at First Methodist Church. The churches display hundreds of nativity sets for public enjoyment during the Christmas season. The sets vary from traditional to modern. Materials consist of wood, china, glass, plastic, ceramic, and other media.

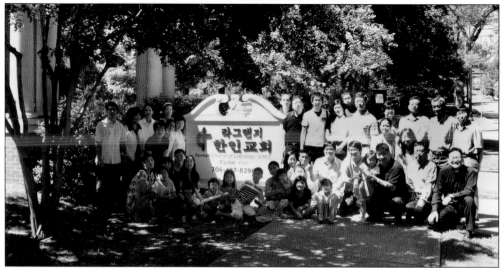

With the arrival of Kia Automotive and other support industries like Sewon America, several churches created programs for and shared their facilities with Korean Christians. Other churches have provided the same for Hispanics. Services are conducted in their native languages and often led by their own ministers. Classes in English are also offered, as they were for the Japanese when NOK opened its doors in the industrial park in 1980.

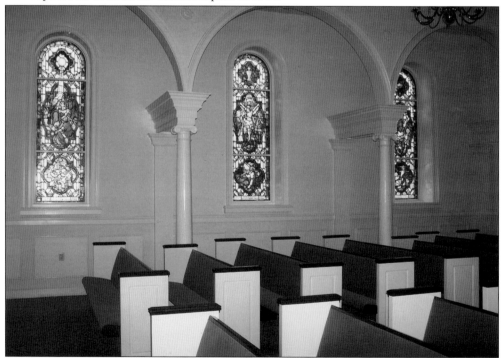

The chapel at First Methodist opened in 2002 as part of a larger project that included the Methodist ministries building. Planning for a chapel began as early as the 1950s. The stained-glass windows were added to the chapel in January 2008 in memory of Ercil Trussell Smith by her husband, V. Hawley Smith, who served as chairman of the Troup County Commissioners from 1979 to 1990. The windows depict the birth, crucifixion, and ascension of Christ.

Five

SCHOOL DAYS

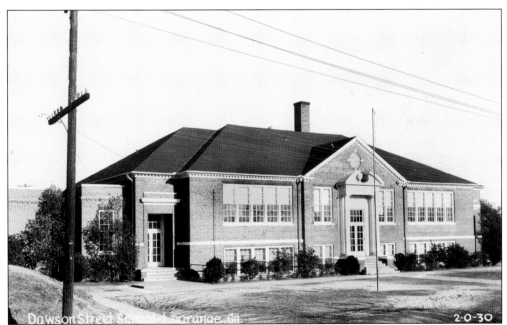

Established in 1922, Dawson Street School served public school students until 1990. Dixie and part of East LaGrange Elementary consolidated and moved to Dawson Street. When the original building burned in 1936, students met for a year at Calumet Community Center. Daniel Lumber Company built this structure, designed by architects Ivey and Crook of Atlanta. Dawson Street Christian Academy and Alpha Multi-Purpose Center now call the building home.

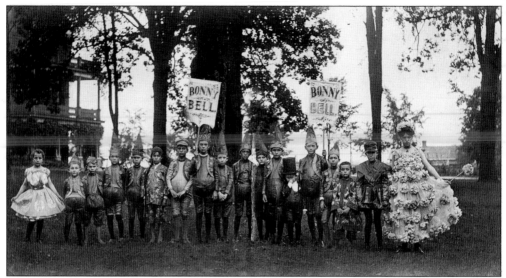

Plays and performances have always been an important part of school life and the culture of the area. Before LaGrange started public schools in 1903, both LaGrange Female and Southern Female Colleges operated primary departments to educate elementary-age children and provide teacher training. *Bonnybell* was a popular pageant based on the story of Cinderella. This Southern Female group, outside the school's Church Street buildings, performed on June 26, 1903. (Photograph by Julius Schaub.)

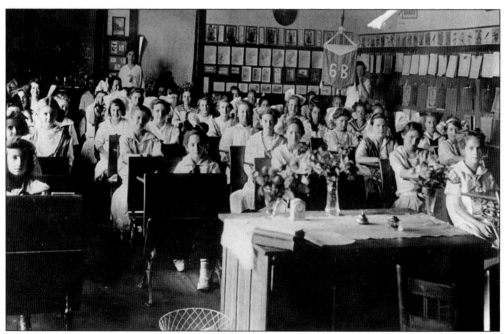

In 1914, these sixth-grade girls at Harwell Avenue posed for the photographer. Built in 1903 to serve all grades, Harwell Avenue became exclusively an elementary school when LaGrange High School was built on North Greenwood Street in 1914. As was the custom of the day, girls and boys had classes in separate rooms. Generations attended school here and later in a building across the street before it burned in 1964. LaGrange Memorial Library now occupies this site.

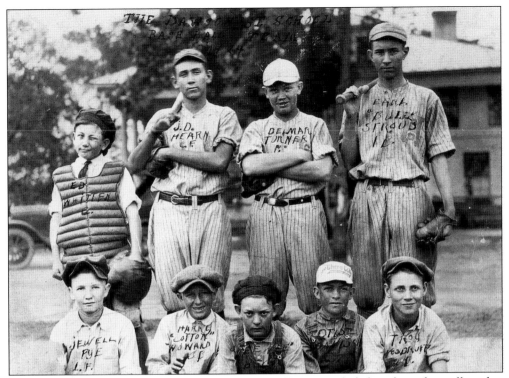

The 1924 Dawson Street Elementary School baseball team included students from all grades. They played ball at the athletic field on Hines Street. They probably played other local school teams. LaGrange has a long tradition of excellence in sports. Though archivists prefer writing on the back margins of photographs, someone inscribed names and positions of the athletes across their chests so their identities would be known to posterity.

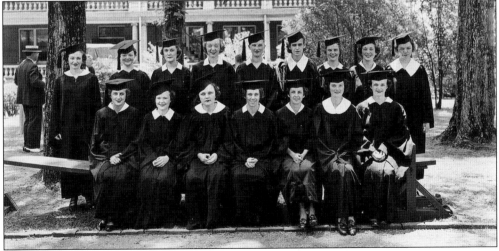

The 1937 graduating class at LaGrange College gathers in the quadrangle on College Hill. Hawkes Hall, built in 1911, stands in the background showing its original three-tiered veranda. The porches were removed in 1950. The college officially dropped the word "female" from its name in 1934. It experimented with coeducation in 1935–1936 but became fully coeducational in 1948, with males living on campus after 1953. Styles for caps and gowns have changed little since the 1930s.

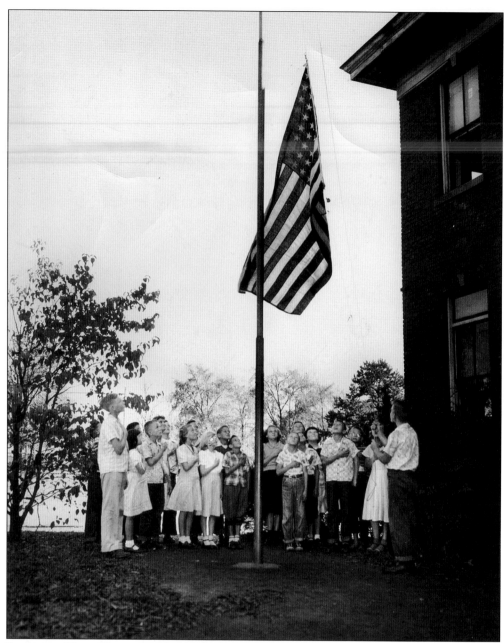

Students at Unity Elementary pledge allegiance as they raise the flag at the start of the school day in the late 1940s or early 1950s. The LaGrange Board of Education created five elementary schools in 1903. Only Unity survives today, though in its third building. The corner of the building seen here was Unity's second structure, built in 1909 on Wilkes Street, which replaced the original building on Callaway Avenue. The current building on the corner of Wilkes Street and Park Avenue opened in 1952 with substantial funding from Callaway Foundation, Inc. After Harwell Avenue School burned in 1964, its students attended school in the afternoon at Unity until the new school on Country Club Road, Hollis Hand Elementary, opened in August 1966. Students today continue to stand each morning for the pledge to the flag and a moment of silence.

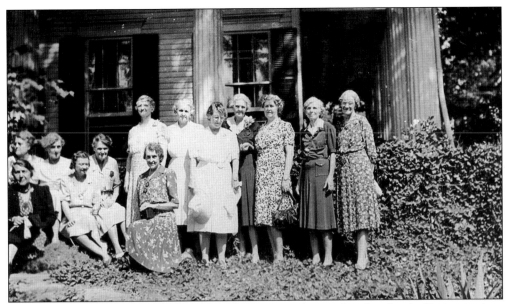

For three quarters of a century, LaGrange had two prominent female schools. Dating back to 1831, the older became LaGrange College. The other, Southern Female College (SFC), operated from 1843 to 1919. These ladies of the SFC class of 1900 gathered for a reunion in the gardens at the Heard-Beall-Dallis house on Broad Street in August 1942. The Methodist Conference has owned LaGrange College since 1857. Southern was affiliated with the Baptist Church. Both schools had noted music departments.

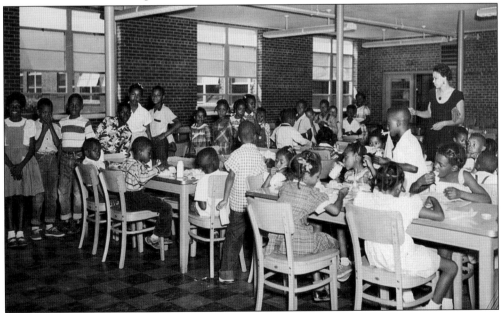

Lunchtime often ranks with playground time as the favorite part of the day for students. Some East Depot Elementary students are enjoying lunch while others wait in line to get their trays around 1960. When built in 1923, East Depot included both high school and elementary pupils. When the upper grades merged with LaGrange High in 1970, the elementary building housed Eastside Primary and LaGrange Boys Junior High. Twin Cedars uses the site today.

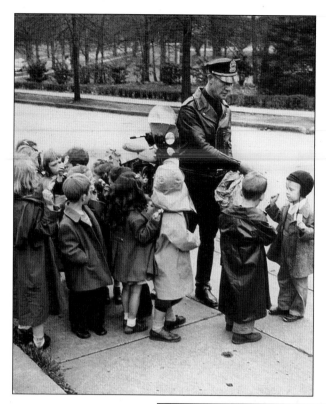

The LaGrange Police Department has long worked with school patrols to ensure the safety of students arriving and leaving school. Motorcycle patrolman Walter Crews helped these Dallis Street kindergarten children and brought them treats, such as the bubblegum he is handing out here in 1949. Later that year, officials of the LaGrange Police Department named him their officer of the year. (*Callaway Beacon* photograph.)

On November 20, 1970, students and townspeople rushed to the campus of LaGrange College as flames ravaged Dobbs Hall. Despite the valiant effort of the LaGrange Fire Department, the building was lost. Named for Samuel Candler Dobbs in 1939, this was the second classroom and auditorium building to stand on the peak of College Hill. The Fuller E. Callaway Building now occupies the site. (Photograph by J. Hugh Campbell.)

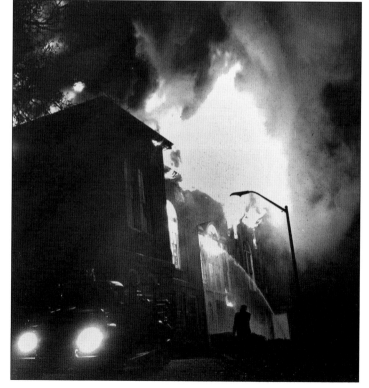

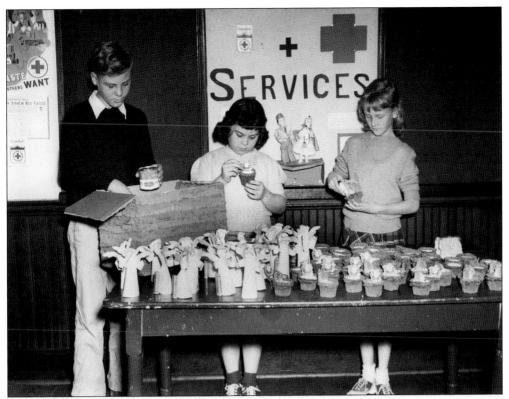

Junior Red Cross programs give students the opportunity to participate in service projects. These Unity School students are shown making and packing canned goods and Christmas gifts for the Veteran's Hospital in Augusta after World War II. Students have also raised money and donated other items to the Red Cross through the years. The club taught its members first aid and other life-saving skills.

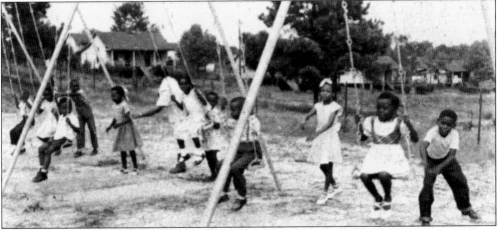

Children enjoy playing during recess at Jones Street School in 1951. Earlier that year, Callaway Community Foundation donated the playground equipment, including swings, a large slide, seesaws, and a jungle gym. The school opened in 1919 on Timothy Street in southwest LaGrange in buildings furnished by Callaway Mills before moving to Jones Street in 1941. The school closed in 1966. (*Callaway Beacon* photograph.)

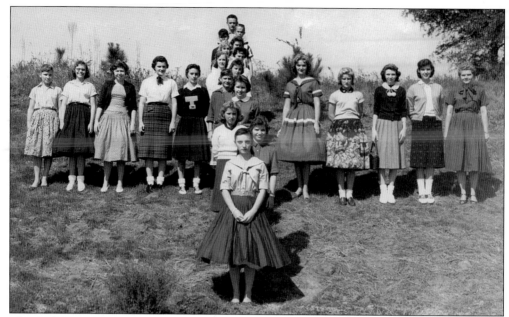

The Red Cross has been popular in local schools since World War I. This group gathered in the mid-1950s on the hill just north of Troup High School, where it formed the shape of a cross. Rolled bobby socks, flared skirts, and saddle oxfords typified women's fashions of the day. Troup High opened on Whitesville Road in January 1956, when the county high schools consolidated. It moved to its current location on Hamilton Road in 1987.

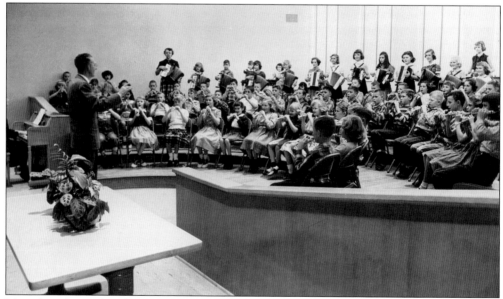

Music has always played an important part of school life in Troup County. The band room in the new Southwest LaGrange School building shows the popularity of instrumental music among students. The built-in theater style of the room, plus other special features, reflected the state-of-the-art design throughout the school. Vannie Sanders served as band director here and at the Callaway Educational Association. The LaGrange Board of Education renamed the school Berta Weathersbee in 1974, honoring its longtime principal.

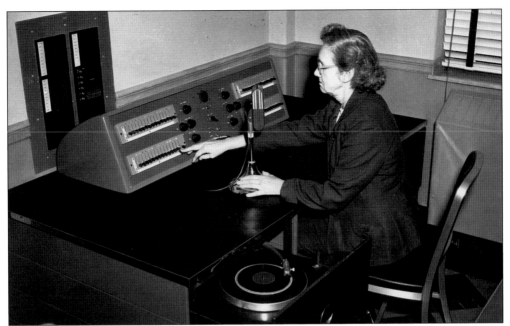

When Newman Construction Company built Southwest LaGrange School on Forrest Avenue in 1953, it included modern technical equipment and facilities. The intercom system allowed the office to communicate with every room or with a single room. Although a standard feature in schools today, this was rare in 1953. The secretary could even play music with announcements. Though most schools have a faculty lounge, Southwest had a faculty dining room furnished with elegant china, silver, and crystal.

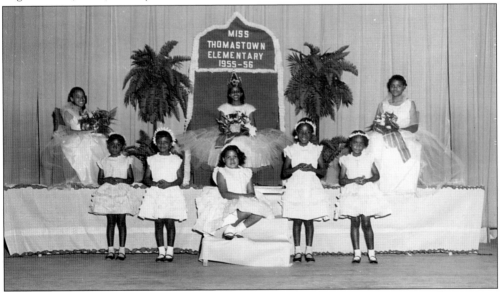

Thomastown Elementary School opened in 1951. Four years later, it held this Miss Thomastown contest. Pageants have traditionally been an important part of school life. Located on Mooty Bridge Road near Ridley Avenue, the school sat in a LaGrange neighborhood named for a prominent black family. The school became Northwest Primary in 1970 and closed in 1985. The building later served as the administrative offices of the school board and as home to Hope Academy.

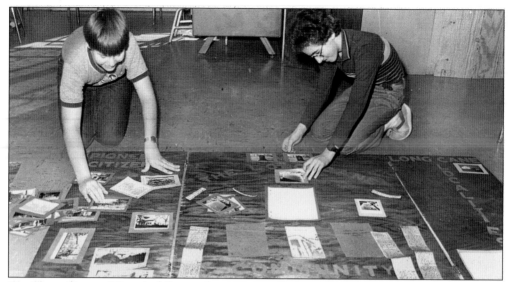

The Troup County Historical Society has sponsored History Day Contests for middle and high school students since 1980. LaGrange College serves as a cosponsor. The national contest includes performances, media, exhibits, and papers focused around a central theme. Local winners Danny Knight and Michael Edmondson competed in the state and national contests in 1984 and 1986. Knight went on to get a PhD at Oxford University and now teaches history at the university level.

Members of the 1976 graduating class of LaGrange Academy gather on the stairs of a local residence for a formal photograph. Most of the students went on to college that fall. LaGrange-area residents founded the school on Vernon Road in 1970. Over the past 40 years, the school has expanded its programs and facilities. For a small school, the Warriors have also had significant athletic success over the years.

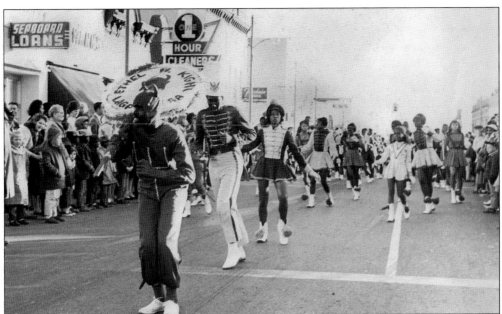

School homecoming parades always draw a crowd in LaGrange. The parades typically feature elaborately built floats and decorated cars along with marching bands and beauty queens. In 1964, the Ethel W. Kight High School Red Devil Band performed as it marched north on East Court Square as part of East Depot's homecoming festivities (above). Traditionally, each school participated in the other's parades. Below, East Depot students Miss Wolverine Jarvis Allen and John Bonner ride down Bull Street after leaving Court Square. East Depot merged with LaGrange High in 1970. The Troup County Board of Education built Ethel Kight School, named for a longtime local educator, in 1955 as it consolidated all the county black schools. All grades attended. The building later housed a junior high and middle school after Ethel Kight merged with Troup High in 1970. Ethel Kight Elementary now occupies the building.

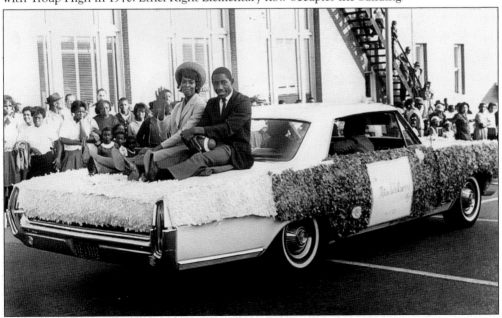

Many individuals and agencies support local schools and the community in promoting literacy. Debbie Burdette has been dressing as Mama Jama since 1995 to encourage students to develop a love of reading. She visits classrooms and appears on local television. Another of her characters, De-Bee, a giant bumble bee, publicizes an annual spelling bee that raises money for literacy projects. She heads the Certified Literate Community and serves on the Troup County Board of Education.

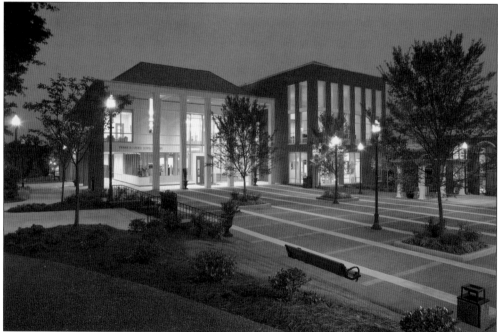

The Frank and Laura Lewis Library stands majestically against the night sky on the LaGrange College campus. College officials dedicated the building on April 17, 2009. At the time, the library became one of only three libraries in Georgia to be LEED certified, designed and built with environmental efficiency in mind. Frank and Laura Lewis both served as librarians throughout their careers. Frank was the first black faculty member and trustee of LaGrange College.

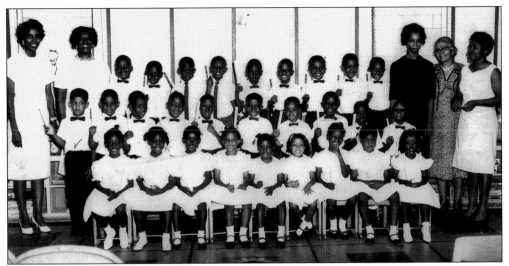

The Maidee Smith Memorial Nursery dedicated its new building on Union Street in September 1951. Callaway Foundation provided the building. The 1962–1963 class gathered for a graduation portrait with its teachers and Dorothy K. Harrison, one of the early founders. The idea originated with Maidee Smith, a longtime professor at LaGrange College. Her Sunday school class at First Methodist Church started the school in the 1940s. The nursery continues to operate today as a United Way agency.

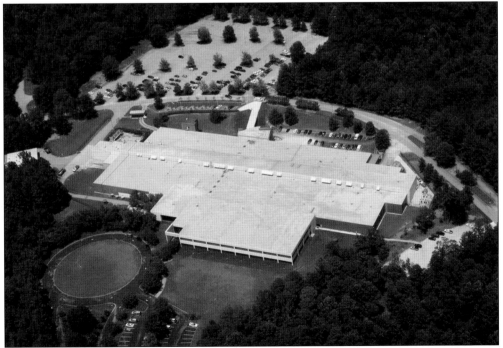

The new campus of West Georgia Technical College, shown here, opened in 2008. It converted the old Hughes plant for this state-of-the art facility. The Troup County Board of Education founded the school as Troup Tech in 1966. Buildings on the original Fort Drive campus remain a vital part of the institution. In 2009, the school consolidated with another technical college based in Carrollton and kept the local name. (Courtesy of Lee Cathey.)

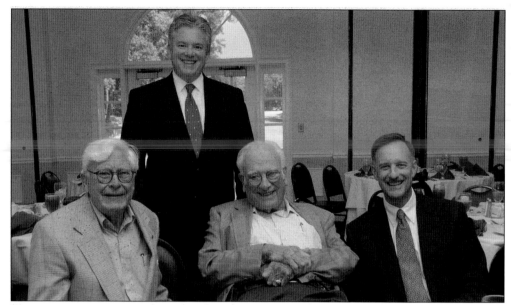

These men represent over three decades of presidency at LaGrange College. Current president Dan McAlexander stands behind former presidents, from left to right, Walter Murphy, Charles Hudson, and Stuart Gulley. They gathered following a Rotary meeting that honored Hudson on September 1, 2010. They all participated in the weeklong festivities surrounding the inauguration of McAlexander as the 34th president of the college. During their leadership, the college increased enrollment, added buildings, and enlarged the campus. (Photograph by Lee Cathey.)

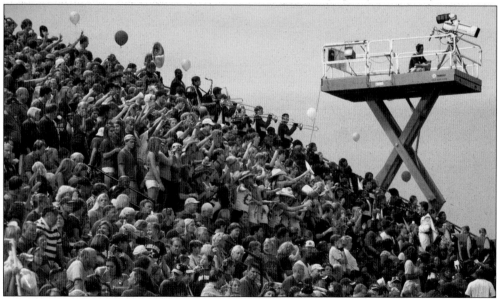

LaGrange Daily News photographer Robyn Miles captured the excitement of the crowd attending the LaGrange-Carver football game at the newly renovated Callaway Stadium on September 17, 2010. Although LaGrange finished the 1991 season ranked number one in the nation, this was the first appearance by a local team on national television. Fans around the world viewed the ESPN2 game. Though LaGrange lost, the Grangers kicked a field goal—the first points scored on Carver that season.

Six

LET US ENTERTAIN YOU

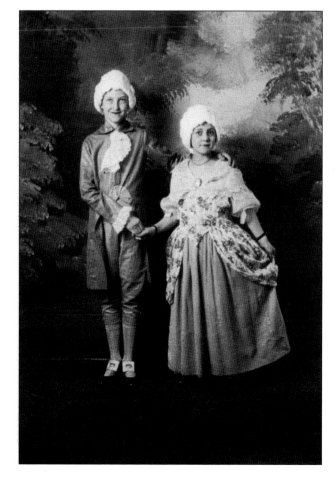

George and Martha Washington came to life in LaGrange often in school pageants each February. In the early 1930s, Mary Page Sargent and Sadie Pike don period costumes to portray the first president of the United States and his wife. They attended Dawson Street Elementary School. In those days, many schools held elaborate pageants throughout the school year, which helped teach students history.

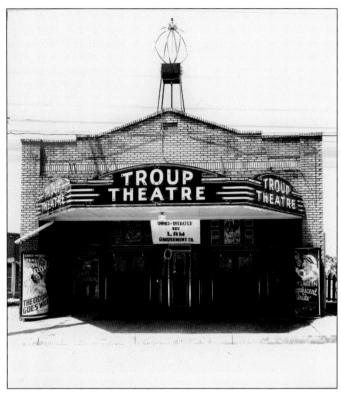

Before large multiplex cinemas, LaGrange had neighborhood theaters. In 1936, the marquee at Troup Theater on Lincoln Street in Hillside (formerly Jablex) advertised *Theodora Goes Wild* as the main feature. The city boasted four other theaters that year, including the Dixie on Depot Street, Family on Oak Street, LaGrange on Main Street, and Ritz on Hill Street. LaGrange Theater, built by Lam Amusement Company in 1930, supplanted the old Fairfax Theater, located a block north on Main Street.

Unity School students dance as part of an elaborate May Day celebration at Callaway Stadium in the 1940s. Other schools may have also participated. The Queen and her court watch from the stands while a pianist accompanies from one of the dugouts. The boys all sport Army caps in a nod to the impact of World War II in their daily lives. Each class probably performed a different dance.

Dance classes and studies have played important roles in the cultural life of LaGrange. The colleges and studios offered private classes while the mills sponsored lessons for children of employees. Annual dance recitals grew into major productions that continue to draw large crowds. Richard and Ann Harris, students at Helen Jackson Studio, bow to each other around 1940. Other longtime instructors included Mary Cleaveland, Julia Hope Johnson, and Jennie Gordy.

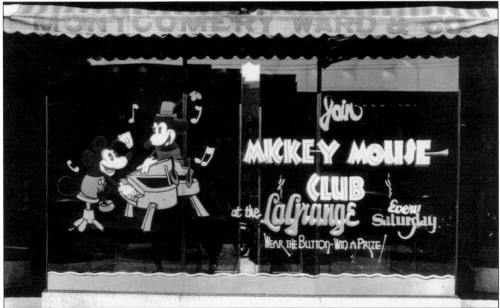

Shopping can be as entertaining as any other form of recreation, especially when large crowds came into town each Saturday. The window at Montgomery Ward, once a major chain and mail order store, reminds shoppers to take their children to LaGrange Theater in the early 1930s. The ever-popular Mickey Mouse was the first cartoon of Disney Studios. Later, the Mickey Mouse Club appeared on television weekly. Gallant-Belk soon replaced Montgomery Ward at this Main Street location.

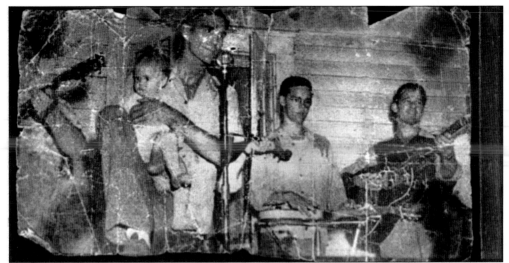

Curtis Mims and others played for a street and square dance on the Fourth of July as they celebrated the nation's independence in 1948. They performed at Dixie Community Center on Dixie Street. The building later served as the senior center until Troup Senior Center opened on Ragland Street in 1993. The singer holds his daughter, Linda Mims, as the band entertains the crowd. The photograph may have been carried in a wallet for years.

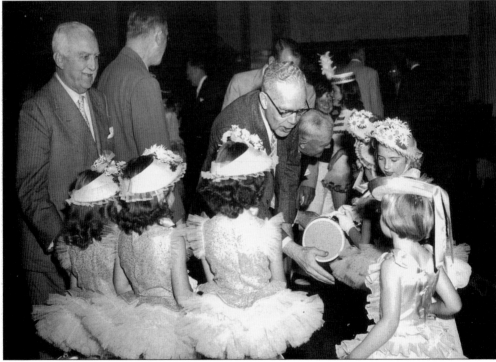

Dance students from the Callaway Educational Association perform at a meeting of the board of directors of Chemical Bank in 1957. Cason J. Callaway served on their board and brought this meeting to LaGrange. He founded Callaway Gardens with his wife, Virginia, in 1952. After the girls performed, the men had the opportunity to thank the little dancers. Such occasions gave the girls a chance to polish their skills.

The best entertainment is often spontaneous and for personal amusement. Curran Easley Sr., a longtime LaGrange resident, and LaRoche Bentz clown around in the early 1900s. Easley moved to LaGrange in the 1920s to work for Callaway Mills. His son, Dr. Curran Easley Jr., served as a much beloved pediatrician in LaGrange for over four decades. Dr. Easley was a torchbearer in the 1996 Olympic torch run.

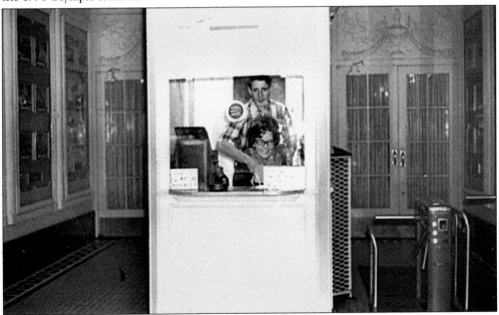

Two employees of LaGrange Theater cut up in the ticket booth for the photographer in the mid-1960s. Beautiful plaster relief work over the entrance and exit doors gives a hint of the grand rococo-style theater lobby just beyond the doors. The building later served as home to New Community Church prior to being razed in 2005 and replaced by LaGrange Cinemas. A theater has operated on Main Street in LaGrange since 1916.

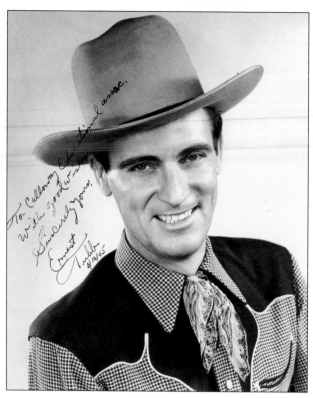

Many nationally known artists have performed in LaGrange and West Georgia over the years. Ernest Tubb, the "Texas Troubadour," gave a concert at Callaway Auditorium on February 10, 1944. His most popular release, "Walking the Floor over You," came out in 1941 and helped popularize honky-tonk music. He joined the Grand Ole Opry in 1943. Country, rock, and pop music legends, comedians, and opera and symphony stars have all entertained local audiences. (Charles Renagar Studio.)

Southwest LaGrange Concert Band, under the leadership of Vannie Sanders, performs a concert on the east side of the square in 1927. The band gathered at the Confederate Statue. In his career, which covered five decades with Callaway Mills, Sanders organized over 40 different bands and orchestral groups and taught over 500,000 music lessons. Some bands were state champions and competed in national contests. Callaway Bands performed frequently for military groups during World War II.

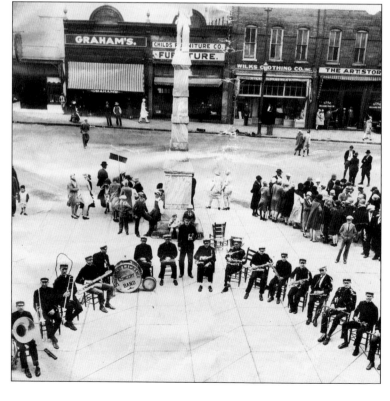

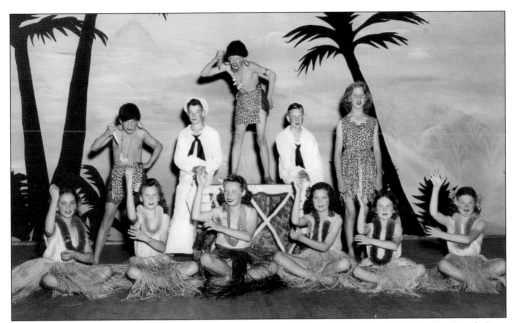

Students at Callaway Educational Association (CEA) celebrated May Day, 1945, in the South Seas rather than around the May Pole. They performed *Sky-Rocket Rhythm* at Callaway Auditorium, which had opened in January 1942. This production took place three and a half months before the end of World War II and four years before the popular Rodgers and Hammerstein musical *South Pacific.* CEA plays always included elaborate costumes and scenery.

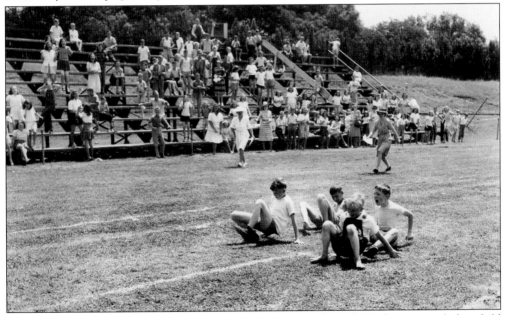

Callaway Educational Association sponsored various events throughout the year, including field days like this one. The "playground Olympics" featured many activities and competitions, such as watermelon-eating contests, cakewalks, and track and field races. These boys may have been competing in pairs in a crab-walking contest. Individual schools continue to hold field days. In the past, entire communities, such as Southwest LaGrange, held similar events for all age groups.

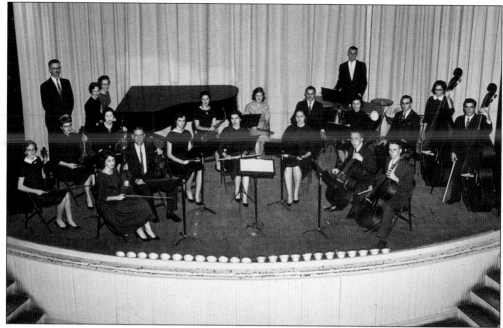

Several times in the past 125 years, LaGrange College and local residents have joined together to provide a community orchestra. Founded in 1958, this one performs at Dobbs Hall on the college campus around 1960. Similar groups of talented local musicians played in the 1870s and in 1909. Historically, the local colleges have attracted prominent music faculty and guest performers to the area. LaGrange Symphony Orchestra evolved from a college-community partnership in 1989.

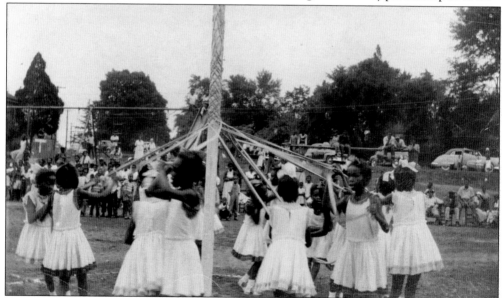

Students at East Depot Elementary participate in a May Pole Dance, a popular springtime event since the Middle Ages. The dance involves skill as girls weave intricate patterns of ribbons around the pole. This event took place in the 1950s. Other May Day events included naming a May Day Queen and court and performances by a marching band. Note that the girls going to the left have different dresses than the girls going to the right.

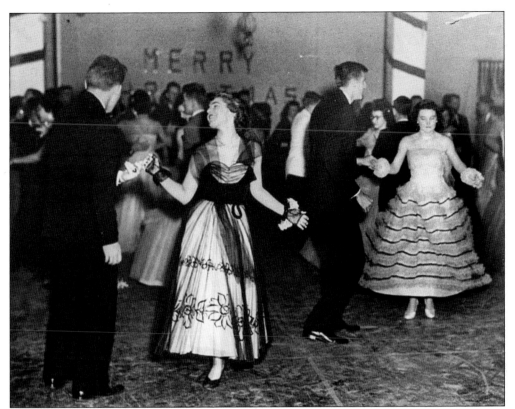

These LaGrange College students and their dates may be doing the jitterbug as they enjoy the college Christmas party in the early 1950s. The women's gowns feature the popular ballerina length. The dance probably took place in the gym located in the basement of Hawkes Hall. Some of these young men may have been among the earliest male students to study full time at the college.

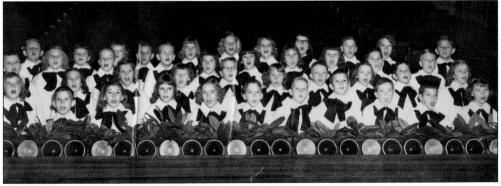

Choral performances and pageants constitute an important part of the Christmas season. Choirs range from children's groups to college performers to church and community groups. In a reversal of the norm, the *Callaway Beacon* photographer stood on the stage to capture these Unity School singers during a dress rehearsal in December 1953. Debbie Ogle founded a professional youth choir, Young Singers of LaGrange, in 1994. Students must audition annually and have performed internationally.

Local residents interested in art and cultural growth formed the Chattahoochee Valley Art Association (CVAA) in 1963. Internationally known artist and LaGrange native Lamar Dodd donated one of his paintings for their permanent collection. Discussing the donation with the artist (below) are Alice Callaway and Ezra Sellers, on right. Sellers served as head of the LaGrange College Department of Art and Design. Dodd headed the art department at the University of Georgia. Both LaGrange College and Georgia have art centers named for him. The CVAA first made its home at 301 Church Street in the mid-1960s in a building that once housed the office of Dr. Hollis Hand. In 1977, it moved to the former Troup County jail, which had been renovated. Since then, both the street and the association have undergone name changes. The organization now calls itself LaGrange Art Museum and is located on Lafayette Parkway.

These boys in Mrs. Williams's first-grade class at Unity School performed as clowns in a sketch called "Tiny Tot Circus" on March 10, 1970. Proud parents and grandparents would fill an auditorium to see their children participate in annual class productions. Besides providing entertainment, school plays offered life experiences for the participants, such as poise, stage presence, and teamwork. Though sometimes schools supplied the outfits, mothers usually had to make, buy, or alter costumes.

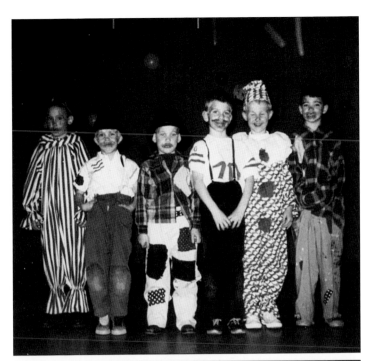

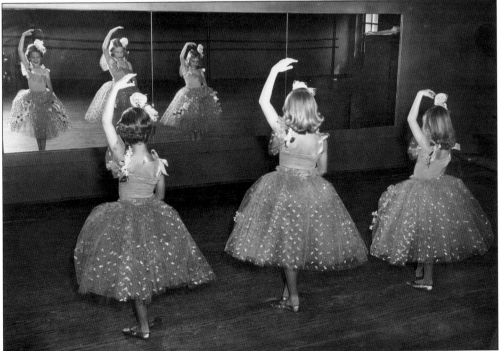

These young ballerinas prepare to take a "Sentimental Journey" at Callaway Auditorium on April 27, 1956, as part of their annual dance revue. In an act titled "Command Performance," they begin to pirouette before the King and Queen in a court scene. Sequences included everything from the minuet to what the *Callaway Beacon* called "bop and boogie and the present day rock and roll." Sue Williams taught ballet under dance instructor Julia Hope Mills.

Clowns have long entertained people of all ages. This group gathers on the steps of Quillian Building on May Day, 1982. Two LaGrange College first ladies, Marianne Murphy, far left, and Mamie Lark Henry, overlook the activities. A May Day highlight has long been traditional step singing, where different campus groups, including sororities and fraternities, compete with their singing and performance skills. Carnivals like this one were often part of the festivities.

Lewis Scarborough designed Price Theatre at LaGrange College, which features curved and tapered walls. Seating about 290, the theater offers an intimate experience for dramatic productions. The name honors Lewis Price, a longtime Callaway executive. Max Estes headed the speech and drama department for many years, including during this construction project, while his wife Martha assisted with musical productions. Dedication of the building occurred in 1975. LaGrange College presents several plays each year, occasionally featuring community members.

72

East Depot High School, noted for its drama department, produced several plays each year. It won third place at the District Dramatic Festival in 1964 with this one-act comedy, *Home for Mother*, directed by Miss Ringer. The 1965 yearbook, the *Wolverine*, reflected the interest in theater by citing a quote from Shakespeare at the beginning of each section. One of his best-known lines, "All the world's a stage," introduced the segment on organizations.

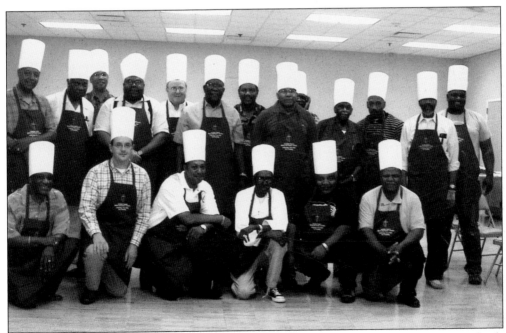

Many organizations and churches work hard to create novel and entertaining ways to raise funds for worthy projects. Warren Temple Methodist sponsors an annual event called "LaGrange Area Men Cooking." They volunteer their time to cook and serve one special dish each to people who have bought tickets for the evening. The church provides entertainment during the event, which is held at Troup County's Mike Daniel Recreation Center. (Courtesy Alberta McMillion.)

The drama department of LaGrange College started Summer Theatre at Dobbs Auditorium in 1965. College students and community residents provided talent for performances. The department presented different plays each year. In 1977, Summer Theatre moved to Callaway Gardens, where it became a regular attraction for garden visitors. After 16 summers at Callaway, the program returned to LaGrange College and Price Theater. Here actresses delight crowds in *Snow White* in 1990.

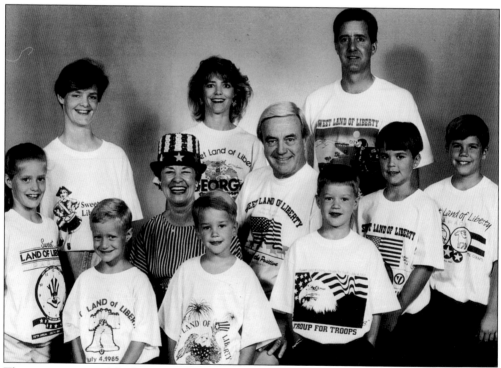

Three generations of the James Boyd family, each wearing a T-shirt from a different year's parade, gathered in 1994 to celebrate the Sweet Land of Liberty Parade for Youth. Annette Boyd, "the parade lady" (center), founded the event in 1985. Designed to encourage patriotism, all participants must be under the age of 19. The parade continues to be a highlight each Fourth of July. The Junior Service League took over sponsorship of the parade after Annette's death in 2004.

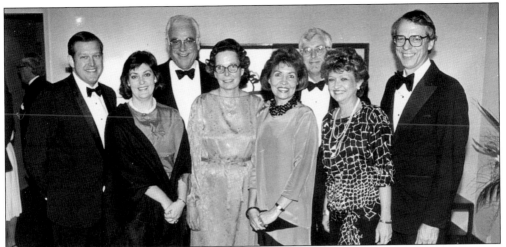

Gathered for a Troup County Historical Society membership gala in 1984 are, from left to right, Pres. Arthur Mallory, Nina Dulin Mallory, Charles and Ida Hudson, Walter and Marianne Murphy, and Dr. Robert and Jenny Copeland. Local citizens concerned about preserving and encouraging a greater appreciation of local history chartered the Ocfuskee Historical Society in 1972. They changed the name in 1981. The historical society operates Troup County Archives and Legacy Museum on Main.

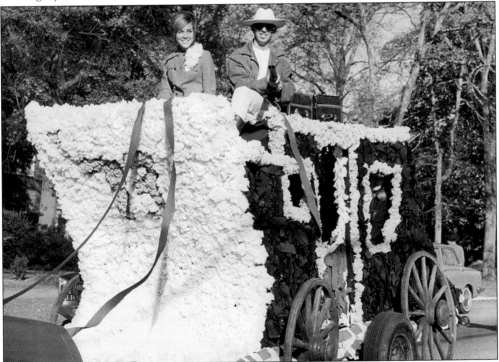

LaGrange residents look forward to homecoming activities and parades at the college and high schools each year. LaGrange College parades tend to be grander productions. The parades always have a theme, which some floats illustrate better than others. Some feature more traditional crepe paper and flowers, while others have a more whimsical flavor. These college students in the late 1960s ride their float in the parade.

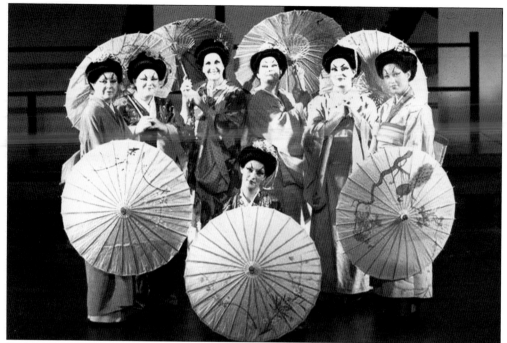

Each summer, LaGrange Lyric Theatre presents a nationally acclaimed musical. In 2008, it gave an outstanding performance of *The Mikado* by Gilbert and Sullivan. Anne Duraski, a professional opera singer, serves as the artistic director of the theater. A nonprofit, membership-based organization, Lyric strives to bring opera and music into the schools. It also offers dinner theater and various productions each year, contributing to the rich cultural environment of LaGrange.

Having served many purposes, this landmark building now houses the Center for Creative Learning of the LaGrange Art Museum. Located at Morgan Street and Lafayette Parkway next door to the museum gallery, the building opened in 1906. Troup County built this as its livery stable and barn just before such places became obsolete. Freeman Feed and Grocery Store, Farmers Supply Store, and a dance and tumbling studio are three businesses that have been here.

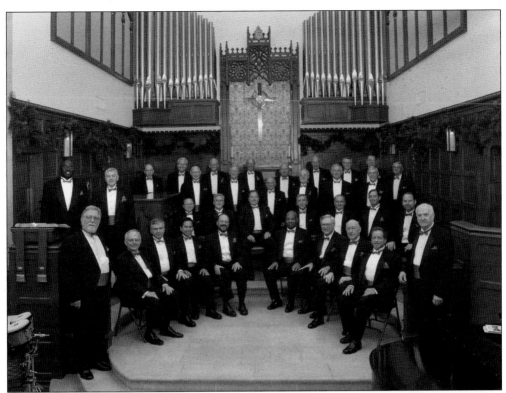

The Sons of Lafayette Male Choir organized in 2001 under the leadership of Loren Pinkerman. It features two ensembles: Re-generation, a folk group; and the Harmonizers, an a cappella group. They have performed throughout the South, in Northern Ireland, and in 2011, at the Cornwall International Male Voice Choral Festival in England. They held a special program to mark the 250th birthday of the Marquis de Lafayette on September 6, 2007.

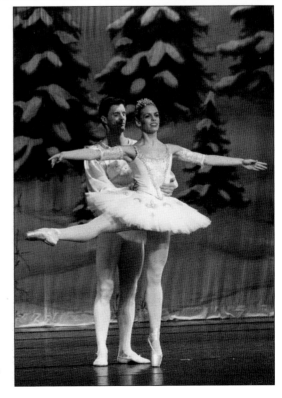

LaGrange Ballet Company first organized in 1987 under the auspices of the Lafayette Society for the Performing Arts with strong support from LaGrange College. It performs *The Nutcracker* each Christmas and other major productions during the year. When it first came into existence, it sought to show that "ballet goes beyond tutus and pointed shoes." In 2007, local star Antoinette Biagi danced the role of Snow with Todd Fox of Miami. She went on to study at Georgia Tech.

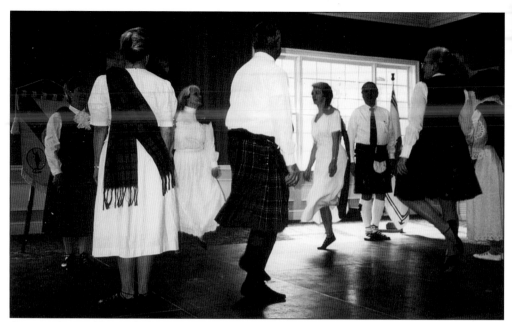

Area residents of Scottish descent joined together in 1982 to form a group devoted to celebrating their heritage called the Order of the Tartan. Through the year, they have special dinners to honor Saint Andrew, patron saint of Scotland, and Robert Burns, the nation's most celebrated poet. They attend Highland games and Kirkin of the Tartans at local churches and participate in Royal Scottish Dancing. This group entertained at a Troup County Historical Society lunch in 2001.

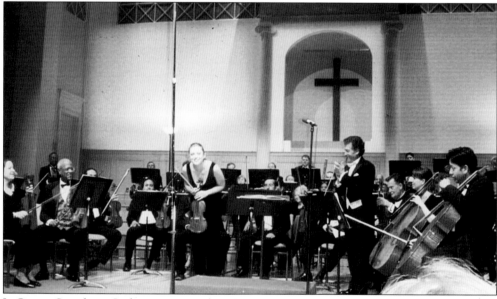

LaGrange Symphony Orchestra organized in 1989 as a joint LaGrange College–community venture and gave its first concert the following year. With its mission being to "enrich the community through music," it performs at least nine concerts each year and sponsors youth orchestras. It also hosts competitions for rising young musicians. LaGrange College named the group its orchestra in residence and it performs at Callaway Auditorium. In 2005, it featured Russian violinist Anastasia Khitruk during a performance at First Baptist Church.

Seven

ALL IN A DAY'S WORK

Richard Jones stands at the LaGrange Depot beside the world's oldest bale of cotton. The cotton had just returned from being displayed at the 1904 Saint Louis World's Fair. His father, Christopher Columbus Jones, ginned the bale in 1870. Jones allowed the cotton to go to Missouri but refused an invitation from the 1900 Paris Exhibition. After years at the Georgia State Capitol, the bale is now on loan to Legacy Museum. (Courtesy of Georgia Archives, Vanishing Georgia Collection, TRP-339.)

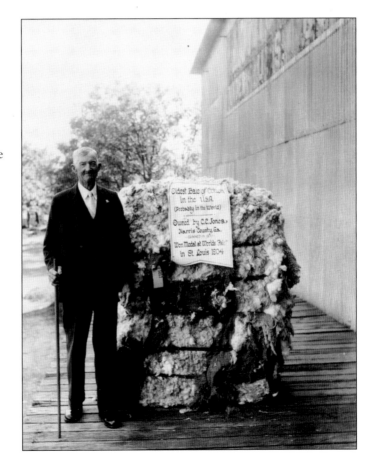

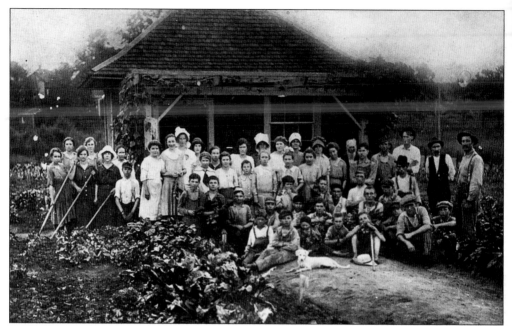

Each of the mill villages in LaGrange set aside garden and pasture land for employees and their families to raise vegetables and keep cows. About 1916, these men, women, and children pause from their labors at the shed in their garden plot at Hillside. Oak Leaf Mills, built in 1928, replaced the garden plot. In 2010, local industrial plants are providing garden plots for local people.

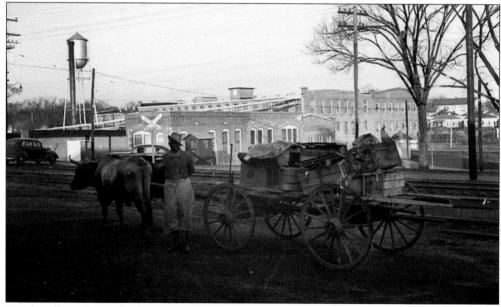

People still used oxen for farming and transportation in the 1930s. This unidentified gentleman stands beside his team as it pulls his junk wagon along the tracks of the Atlanta, Birmingham & Coast railroad parallel to Morgan Street. The cars are crossing the track at the east end of Broome Street with Calumet Mill in the background. Originally named LaGrange Cotton Mill, Calumet began operation in 1889 as the first textile factory in town. (Photograph by Stanley Hutchinson.)

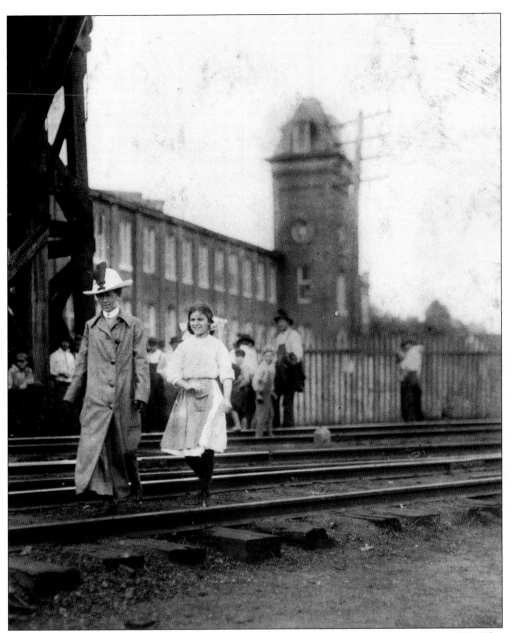

Lewis Hine, National Child Labor Committee photographer, took this image in 1913. The US Department of Labor, created in 1913, used his photographs as evidence that child labor needed regulation. Taken in LaGrange at Consolidated Cotton Duck Mills, later Calumet, the accompanying identification stated that the 12-year-old girl worked in place of her father when he was not sober. The woman may have assisted the photographer or been a social worker. (Courtesy of the Library of Congress.)

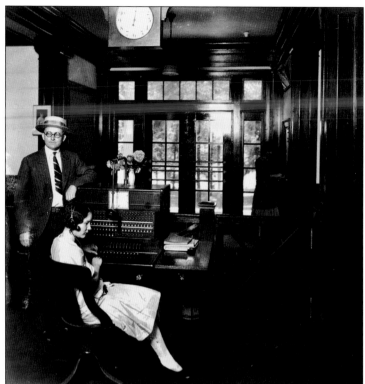

At one time, large companies needed their own switchboards. An operator handled incoming and outgoing calls. This young lady fielded calls about 1930 at the general office of Callaway Mills. Located on Dallis Street, the offices occupied a building called the Martha Washington Inn that originally housed female employees. When Wade W. Milam established the first telephone exchange in LaGrange in 1895, a central switchboard located in the 200 block of Greenville Street connected his 28 subscribers.

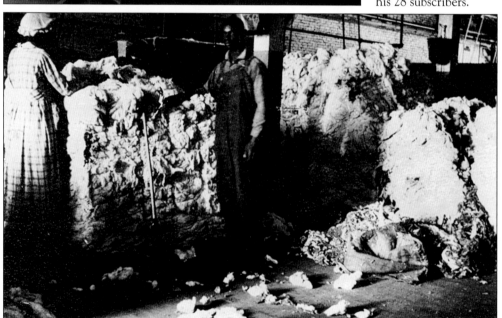

The manufacture of textiles involves many different jobs. The first step at the mill took place in the opening room. Both men and women worked as openers. They removed the bagging and ties of bales from cotton warehouses. Next they fluffed the compressed cotton into small lumps and pitched it into the hopper of the first machine, which thoroughly mixed and pulled to pieces cotton from different bales.

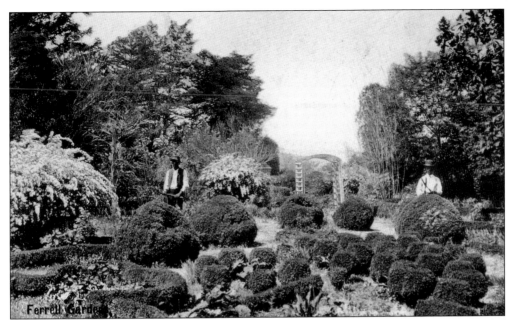

These men wielding hedge clippers in early 1900 represent a long line of those who have tended Ferrell Gardens since 1832. LaGrange once boasted over 100 formal gardens of various sizes, all of which required hours of hands-on attention each season. Boxwood must be kept trimmed, weeds eliminated, and flowers pampered. Alice Callaway, who cared for Ferrell Gardens for over 60 years, often said, "One never knows what evils might befall a garden during the night."

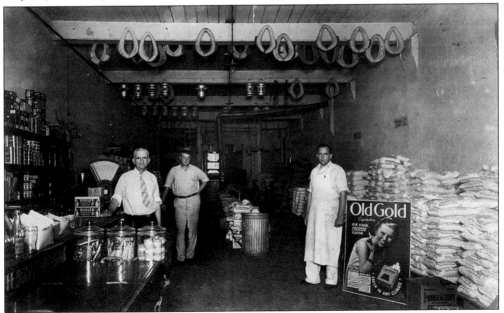

W.M. McClure (center) and Otis M. Williams (left) opened this feed, seed, and grocery store at 107 Bull Street in 1932. Raymond Worley (right) clerked in the store before becoming manager of a laundry and later co-owner of a service station. This business offered many of the same items that old plantation supply stores once carried, though on a smaller scale. Interestingly, the cigarette poster targeted women in this pre–World War II advertisement.

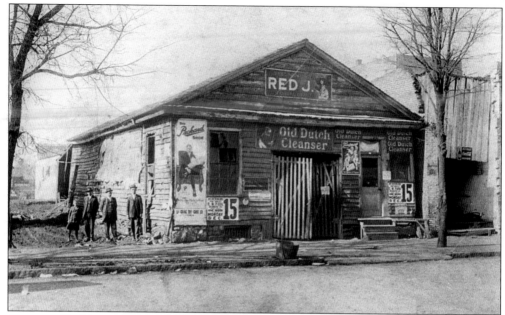

Christian N. Pike operated a furniture store in this building on Main Street as early as 1860. Johnson Stable Company was the building's last occupant prior to being demolished in 1914. The three men pictured here, sons of C.N. Pike, owned Pike Brothers Lumber Company, which constructed a new building on the site that year. The young boy, Henry Pike, stands next to his father, C.N. Pike Jr.

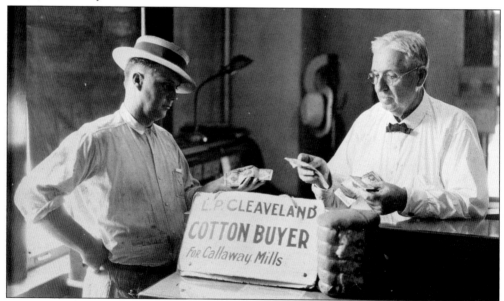

Cotton generated more jobs locally than farming and manufacturing. Many middlemen were involved, including positions associated with ginning, baling, storing, and transporting cotton plus buying and selling. These people made their living from cotton. This photograph originally had the label "Taking the Cash." Lovic P. Cleaveland, right, counts out payment for cotton that had been stored at Troup Warehouse on Morgan Street about 1927. (Courtesy of Georgia Archives, Vanishing Georgia Collection, TRP-283.)

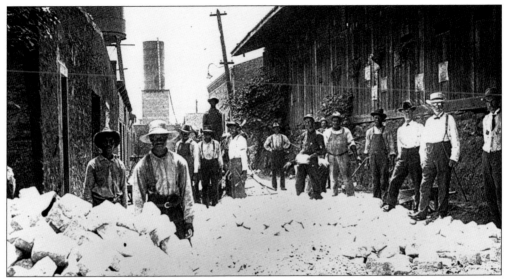

In the first decades of the 20th century, LaGrange residents welcomed street paving as a sign of great progress. In the days before paving machines, the work required much time and intense labor. Each stone had to be manually placed to achieve a relatively smooth and uniform service. These supervisors, workers, and onlookers stand near the old cotton gin on the corner of Morgan and Hines Streets (now Lafayette Parkway).

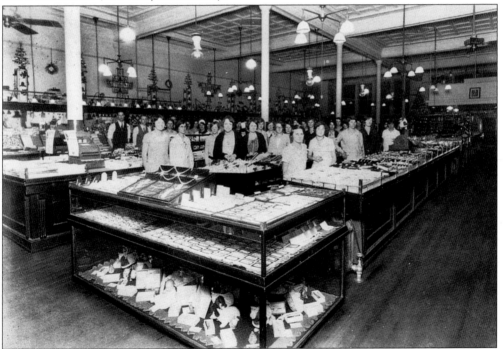

The S.H. Kress Company five-and-dime chain built and opened its LaGrange store on Main Street in 1913. In this 1926 photograph, its 31 employees stand behind neatly arranged counters. The manager, William Sutherland, later became acting president and chairman of the board. The LaGrange store and its neighbor, McLellans, underwent a major renovation and reopened in 2011 as Del'avant with space for public events, offices, and apartments.

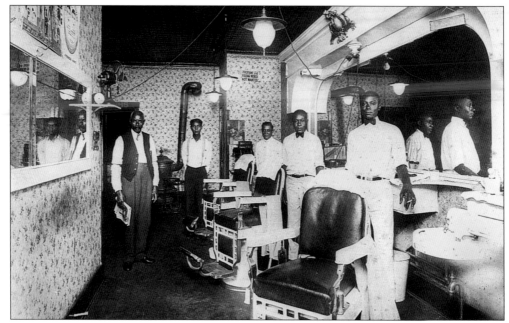

Barbershops and beauty parlors continue to be popular businesses where conversation comes with the service. People once congregated there mostly for company, gossip, and to play games. Sometimes, discussions became heated, as indicated by the sign in the Thomastown Barbershop, which read, "Profane and Vulgar Words not wanted." Thomastown, which lies just north of LaGrange, honors Kate and Wilkins Thomas, both born into slavery but who died as much-beloved and successful citizens.

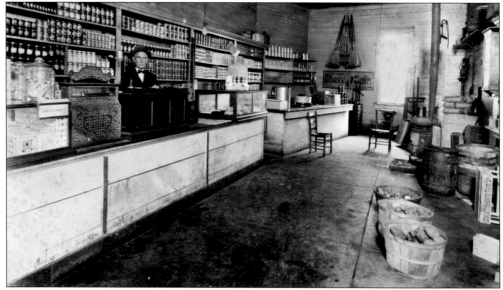

In the 1920s, E.G. Walker Store stood at 500 Hill Street, next to the current Hunter-Allen-Myhand Funeral Home in a fashionable residential neighborhood. During his long life, Walker owned many enterprises around LaGrange, including ones in Harrisonville, on Court Square, and on Ridley Avenue. He also served on the LaGrange City Council when it first paved the streets around the square in 1906. (Courtesy of Georgia Archives, Vanishing Georgia TRP-58.)

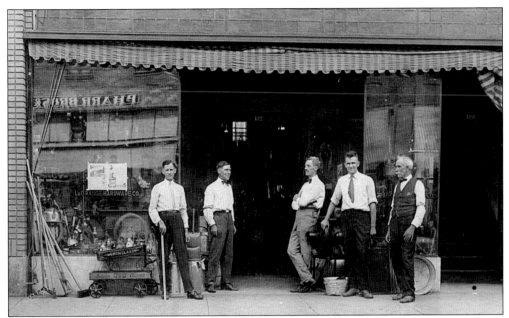

Hardware stores operated in downtown LaGrange from 1879 until about 1990. LaGrange Hardware Company, located at 122 Main Street, opened in 1914. Henry and Bill Jarrell bought Hanson Hardware and Furniture Company and renamed it. Bill operated the store for 44 years. Henry went on to a prominent military career, highlighted by service as a US advisor to General Franco in Spain and Chiang Kai-shek in China. (Photograph by Stanley Hutchinson.)

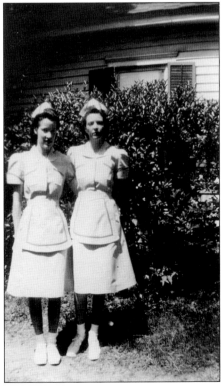

Tasty Coffee Shop opened on Main Street in 1940. Otis Anderson managed the café for over 20 years. Two waitresses pose on their way to work in neat, heavily starched uniforms. A uniform, cap, and apron are displayed at Legacy Museum on Main. Tasty Coffee moved to South Court Square just in time to be a victim of the Park Hotel Fire in 1953. It relocated to Main Street while awaiting space in the newly constructed Mallory-Hutchinson Building.

During World War II, local Red Cross volunteers assisted servicemen in local stores by writing letters and making purchases. Behind the counter, Clyde Lovejoy (later Stevens) greets Lila Quillian, wife of LaGrange College president Hubert Quillian. Mr. Quillian served as president of local Red Cross efforts. Fokes Drugstore opened in 1940 at 106 Main Street as part of Park Hotel. The hotel fire of 1953 signaled the end of the store. (Photograph by Stanley Hutchinson.)

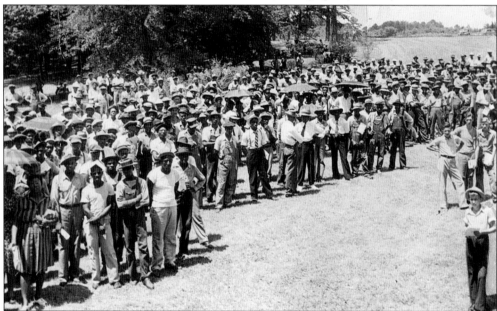

During World War II, the Army and Navy presented awards for excellence to businesses and industries that made major contributions to the war effort. Military officers visited local communities to present the E Awards, often with great fanfare. Several local companies received this recognition. These Callaway Mills employees represent only a portion of those gathered for this special occasion.

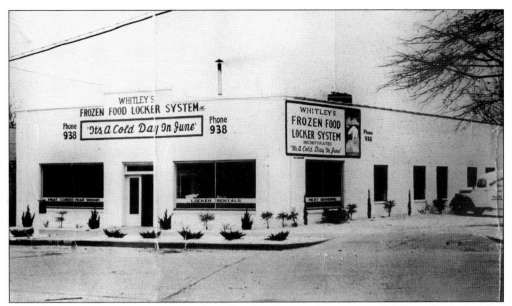

Some businesses exist to meet a need until technology and greater availability of merchandise make them obsolete. Whitley's Frozen Food Locker System opened on the north side of Greenville Street in 1939. A group of prominent citizens, headed by Rufus Newman, bought the enterprise in 1943 and renamed it LaGrange Freeze Plant. By 1950, the greater availability of home freezers and refrigerator-freezers ended the need for this business. Later owners adapted the building for use as a dry cleaners.

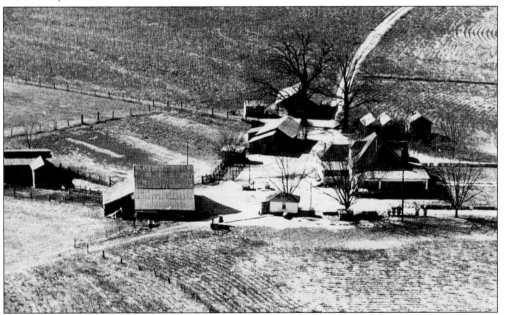

Butler and Ida Evans started their prosperous farming enterprise on Hamilton Road in 1920. A dairy, blacksmith shop, chicken coop, and smokehouse clustered together around their sprawling family home. They raised wheat, corn, cotton, and pecans. Interstate 85 divided the farm when constructed in the 1970s. The house was razed in 1986. Troup High and Lafayette Christian School now occupy the site.

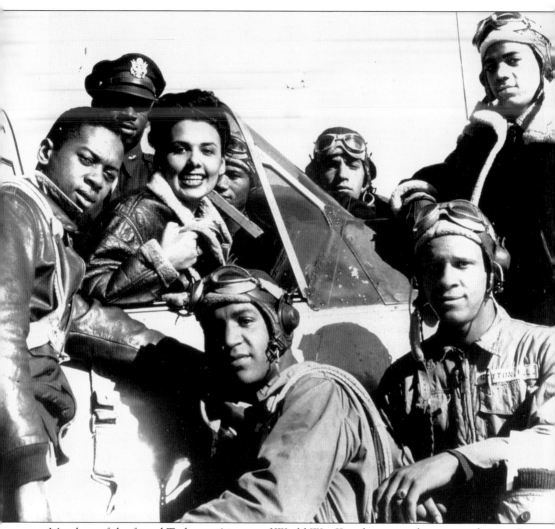

Members of the famed Tuskegee Airmen of World War II gather around actress and singer Lena Horne at their Alabama base. LaGrange resident Willie Fuller, behind Miss Horne and wearing the hat, flew 76 combat missions over Europe. He married Willie Dunson, a LaGrange native, and owned and operated the first black taxi company in LaGrange and worked with the Boy Scouts. He died in Miami in 1995, having served several decades as a Boy Scout executive in South Florida.

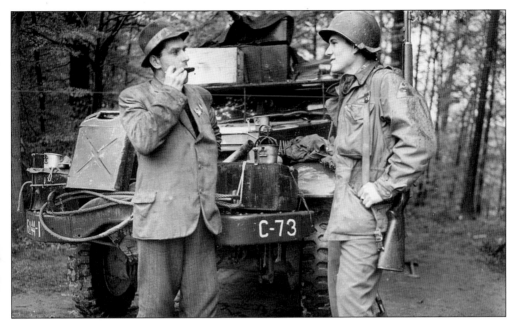

Seale Hipp, right, served in the 4th Armored Division of the US Army during World War II. After advancing into eastern Germany, his company freed Nazi prisoners of war. This liberated Russian slave laborer played his harmonica as Hipp listened in the woods near Lunzenau in the Saxony region of Germany in May 1945. The Army cleared this photograph for publication. Seale returned to LaGrange and practiced law for six decades.

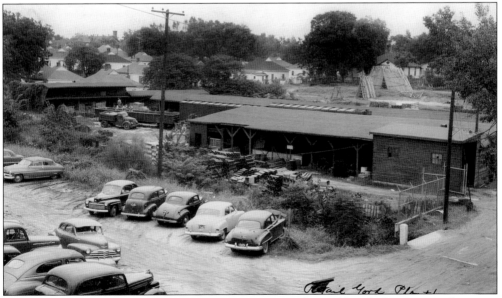

Rufus Newman and Tom Hutchinson bought LaGrange Lumber and Supply Company on the corner of East Depot and Whitesville Streets in 1922. Within five years, they entered the construction business, and in 1932, they reorganized as Newman Construction Company. Lumber and building supplies continued to be a major part of their business, as this c. 1949 photograph shows. Before closing in 2004, the company had built many homes and businesses as well as landmarks like Callaway Tower and Dunson School.

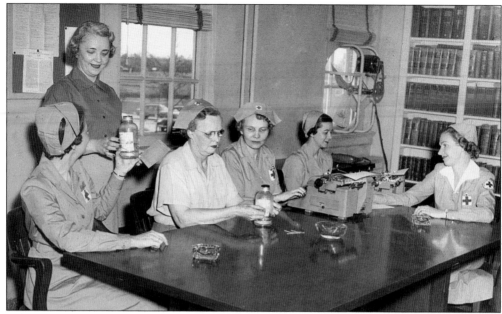

These Red Cross volunteers prepare for a blood drive in the 1950s. The Troup County Red Cross chapter organized in 1917 during World War I. Glass bottles for blood, a manual typewriter, and ash trays on the table would not be seen today. Volunteerism has always been an integral part of life in LaGrange. Many nonprofit agencies depend on the donated labor of interested and compassionate citizens.

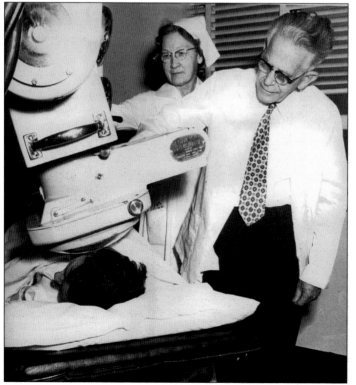

Dr. Enoch Callaway and his nurse ready a patient for x-rays in 1956. As a pioneer in treating cancer, Callaway began serving cancer patients at an indigent clinic he helped establish in 1922. After his two-year-old daughter died of cancer in 1931, he devoted his life exclusively to cancer. In 1937, he established and headed City-County Hospital Cancer Clinic, which later became West Georgia Cancer Clinic. In 1975, the hospital renamed the clinic in his memory.

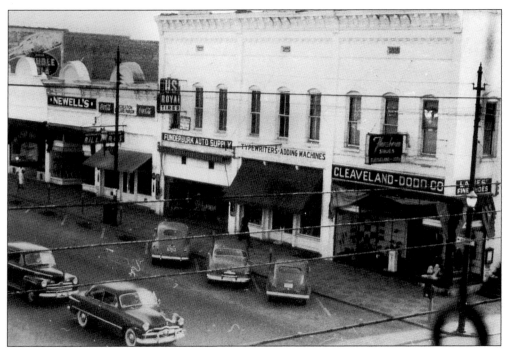

The downtown square formed the original business district of LaGrange. This view of East Court Square shows Funderburk Auto Supply, which moved down the street in 1955. Lehmann's Jewelry, called West Georgia's oldest business in 1880, operated from 1857 to 1978. Pearce Cleaveland established a record that may never be broken. He had worked on the square for 77 years when his clothing business, Cleaveland-Dodd, closed in 1994. None of the businesses shown here exist in 2011.

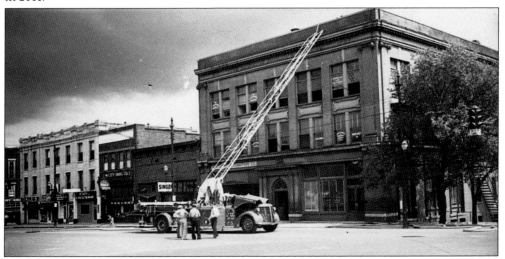

The need for fire protection continues over the generations. Members of LaGrange Fire Department test their ladder in the mid-1940s. Decades later, in 1995, the building on the right, LaGrange Banking Company, burned. The 1906 building had been covered with an aluminum facade. Many remember an enormous inflated pink sofa on the roof in the early 1990s as a furniture store advertisement. The building second from left is the only one to have escaped fire. (Photograph by Stanley Hutchinson.)

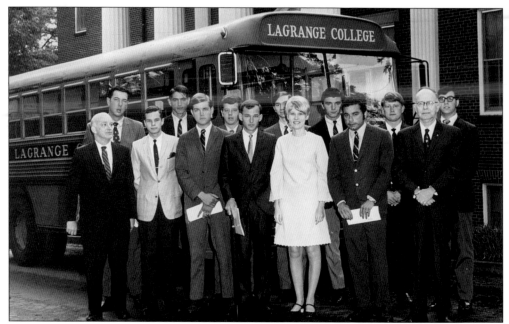

This LaGrange College business class readies for a tour in 1969. Professors Zachary Taylor (far left) and Charles Allen (far right) led the trip. Such outings gave economics and business administration majors a firsthand look at commercial enterprise. As early as 1870, with all female students, they took similar trips to visit factories in Atlanta. Note the students, who include only one woman, wore their Sunday best, as they would for any campus trip. (Photograph by Hugh Campbell.)

Historic houses require constant maintenance and occasionally major renovations. In 1974, the LaGrange Woman's Club, owner of Bellevue since 1941, undertook a significant updating of the structure. Benjamin Harvey Hill built this as his family home in 1854–1856. Workmen from Traylor Construction Company removed the massive Ionic columns for repairs. Listed in the National Register of Historic Places, this is the only Troup County structure to be named a National Landmark.

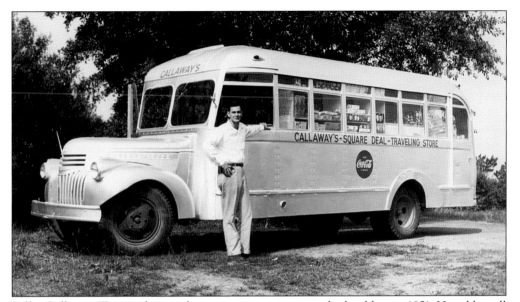

Fuller Callaway III started a traveling store using a converted school bus in 1951. He sold small household items, including foods, spices, and sewing notions. Seventy years earlier, his grandfather traveled on foot with a backpack selling similar items to farm families between LaGrange and the Long Cane community. Soon after this picture, the younger Callaway moved to California, where he established several successful businesses and became a noted yachtsman.

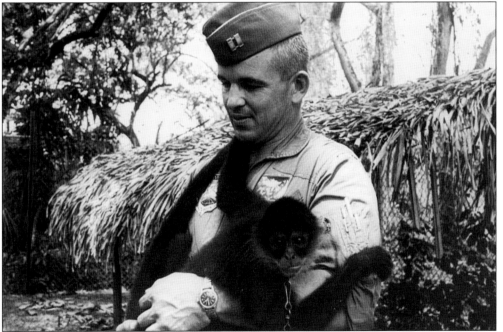

Some careers have both glamorous and dangerous aspects, especially the military, police, and fire service. Capt. Joe Glenn Hyde Jr., a LaGrange High and University of Georgia football star from 1946 to 1952, flew a U-2 spy plane over Cuba, obtaining vital information for the security of the United States. He died when his plane crashed in November 1963, a year after the Cuban missile crisis. Here he plays with a monkey while on leave.

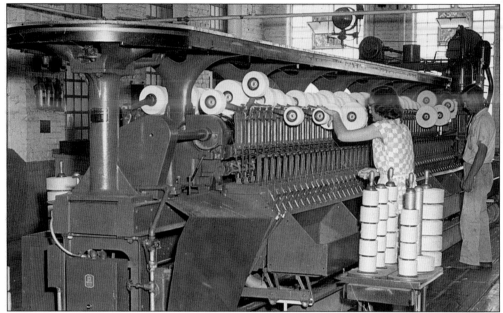

These two textile mill operators work their machine in October 1953. They labored in one of the Callaway Mills in southwest LaGrange. Callaway also operated plants in Manchester and Milstead, Georgia, and Truline Mills in Roanoke, Alabama. The number of women employed by the mills increased greatly during World War II, a trend that continued afterwards. Deering-Milliken purchased the Callaway plants in 1968.

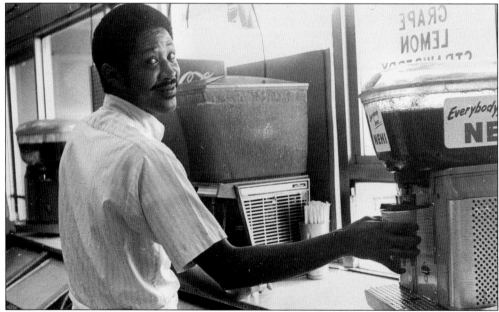

Clifford Russell, better known as "Cuz," stands at the to-go window of Charlie Joseph's Hot Dogs in 1970. He served customers for over 40 years. Such a long working tenure in the food service industry is highly unusual. When he died on May 22, 1998, a *LaGrange Daily News* editorial declared, "The community-wide outpouring of grief at his death proves his influence extended far beyond the swivel stools of the lunch counter." (Photograph by Jenny Copeland.)

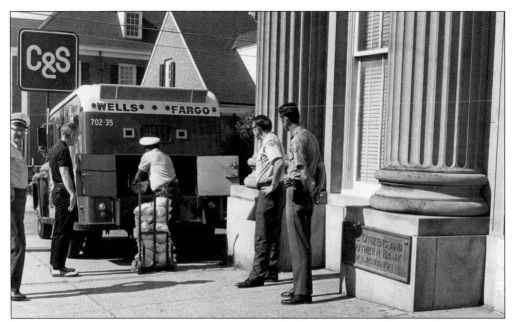

Wells-Fargo and its guards transferred the money when Citizens and Southern Bank moved to its new building at 200 Main Street in 1969. The guards used the armored car for security purposes, even though the bank only moved across Broome Street. Citizens and Southern eventually became Bank of America, and the old C&S building on the right houses Legacy Museum on Main and the Troup County Archives. (Photograph by Hugh Campbell.)

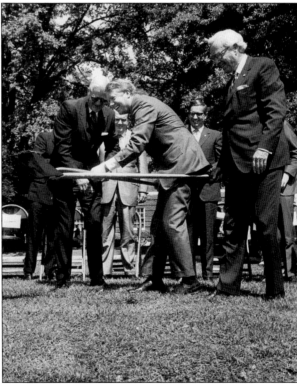

In 1971, Georgia governor Jimmy Carter helped break ground for a six-story addition to City-County Hospital. He joined W.H. Turner (left) and Fuller Callaway Jr. in turning a spade of dirt with a three-handled shovel. Turner served as chair of the Troup County Board of Commissioners, and Callaway represented Callaway Foundation, a major donor. LaGrange mayor Gardner Newman (rear left) and Horace Thom are in the background. In 1975, the hospital became West Georgia Medical Center.

Fifteen years after creation of LaGrange Industrial Park, Hughes Aircraft built a plant here in 1984. The Hughes plant played a major role in weapons superiority for America until 1999, when the plant closed. It manufactured bomb parts, anti-tank missiles, and part of the Bradley Fighting Vehicle. Diethard Lindner, the last president of Hughes Georgia, remained in LaGrange and played a major role in bringing Kia Automotive to Troup County in 2009. This employee inspects a missile guidance system.

The medical professionals and facilities in LaGrange remain on the cutting edge of modern medicine, comparable to those found in much larger cities. Here, Dr. Paul Major (left), anesthesiologist Dr. Jaiwant Avula, and Dr. Grant Major perform surgery at West Georgia Medical Center. The Major brothers are second-generation doctors in LaGrange. Their father, Dr. Cecil Major, practiced at Clark-Holder Clinic for over 40 years. Doctors were among the first settlers of LaGrange, which was rare for a frontier town.

Eight

LEISURE LIFE

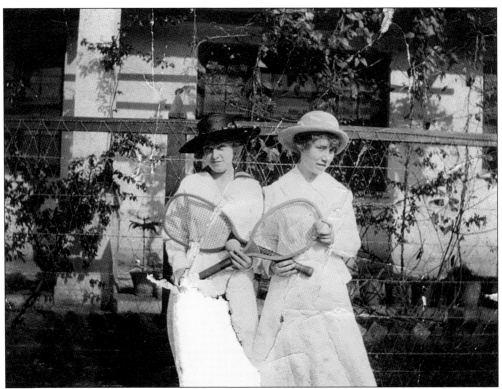

These LaGrange Female College students, dressed in the sporting regalia of the day, await their turn at the net in the late 1910s. Tennis in LaGrange has become both a leisure activity and a competitive sport. The grounds of private homes boasted the first known courts in town. Since the early 1900s, courts have been found at colleges, schools, country clubs, and public parks. The girls may have been at the old LaGrange Country Club on Roanoke Road.

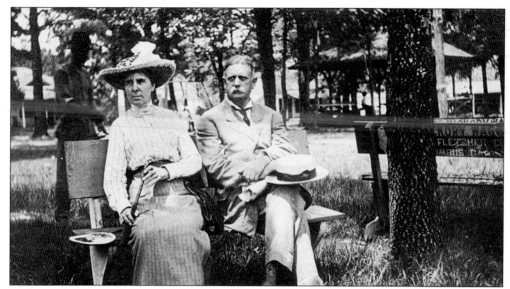

Phillip and Ada Mendenhall Awtrey relax on a bench at Callaway Park around 1910. They lived on Vernon Road, while the park stood between Dallis Street and Forrest Avenue. Public parks and cemeteries often featured bandstands, such as the one behind Awtrey. The building that housed Coleman Library later occupied the site. Awtrey worked as a cotton broker and invested in Callaway Mills. A noted artist, his wife taught in local colleges and was renowned for her portraits.

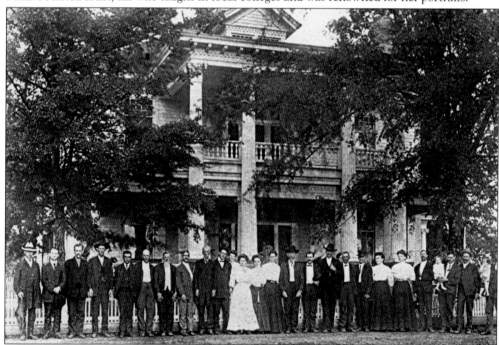

Members of the Pike family gather at the home of John and Annie Copeland Pike at 309 South Lewis Street close to the beginning of the 20th century. Three Pike brothers, Frank, Nat, and John, owned and operated Pike Brothers Lumber Company. They built Unity, Elm City, and Manchester Mills and LaGrange City Hall. At one time, South Lewis had many grand neoclassical homes. A dentist office now occupies the site.

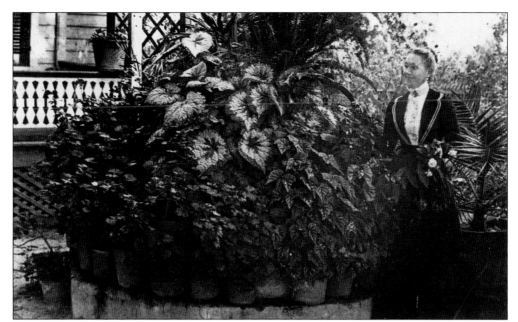

Gardening has always been a hallmark of life in LaGrange. About 1900, Harriett Glanton, wife of Samuel P. Smith, admires an unusual display of plants in her garden at 300 Whitesville Street, just south of downtown. Sam Smith built most of the structures in that block of Whitesville, including South LaGrange Methodist Church, now Bethlehem Christian Church. Note that the plants are in their own pots, which allowed them to be taken inside during the winter months.

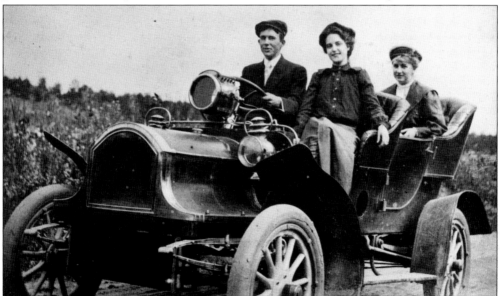

Driving around town or through the countryside has long been a popular leisure activity, whether one traveled by carriage, automobile, motorcycle, or bicycle. This happy trio on October 18, 1905, might have consisted of a couple and mother-in-law or chaperon. Even though the 1904–1905 Buick sported wood-spoke rims and had the optional headlights, these early cars broke down often, and proper young ladies sought to avoid being stranded. (Courtesy of Georgia Archives, Vanishing Georgia Collection, TRP-4.)

Dr. Reuben Shirley O'Neal, born in 1886, played football in 1908 at the Medical College of Georgia, where the football program had only started two years earlier. O'Neal practiced medicine in LaGrange and served in World War I and in the state guard in World War II. A dedicated public servant, he was the first president of LaGrange Lions Club in 1929, a 50-year Mason, and mayor of LaGrange when City-County Hospital opened in 1937.

These Rotarians gathered for a picnic in 1937, perhaps at the newly compounded Piney Woods Lake. Known for its many philanthropic projects, the Rotary Club makes time for fellowship in addition to weekly meetings. At this gathering, member George Cobb served as host. As the area Coca-Cola bottler, Cobb served only "the real thing" and no other beverages! The Rotary Club of LaGrange organized in 1923 under the sponsorship of the West Point Club.

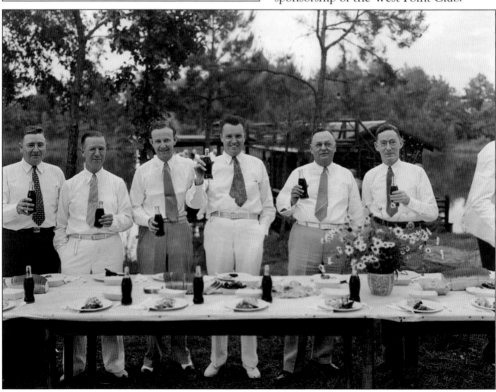

A large and enthusiastic crowd gathered for the opening of Highland Country Club in July 1923. Golfers and spectators appear to be moving toward the first tee on the far right. Famed course designer Donald Ross laid out the original holes. The clubhouse seen in the background burned during the Christmas holidays in 1924. Noted Atlanta architect Neel Reid designed a new clubhouse, which stood for more than 40 years.

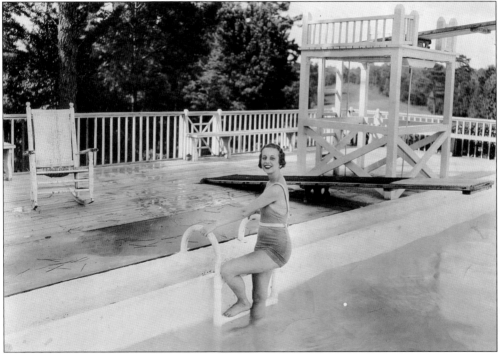

Miss LaGrange 1933 Sally Lane (later Culpepper) enjoys the pool at Highland Country Club. The club installed its first pool in 1923. Like many other pools, this one had a diving board and a high dive from which young people loved to do acrobatic stunts. Over the years, beauty contests have expanded to include all ages from infants to young women to senior citizens. In some of the contests, winners advance to state and national competitions.

In the summertime, sunbathing and swimming often go hand-in-hand as leisure activities. Here, Fuller Callaway Jr. and his wife, Alice, relax by Lake Callaway in the late 1930s. Note the design of the period deck chair. The Callaways developed a country getaway with a cabin, called Countryside, and the lake west of LaGrange. The family often entertains and hosts civic clubs and other groups there. In the 1970s, many others began building second homes at West Point Lake.

H.S. and Jennie Lou Wooding pause for a photograph by their 1936 Ford on a LaGrange street. An institutional or commercial structure appears on the left next to a Victorian home. Side panels reveal the reflections of three other cars parked diagonally across the street. Wooding managed Callaway Department Store on Main Street and later Wooding's Gift Shop. The Woodings built the Neel Reid–designed house at 1004 Broad Street.

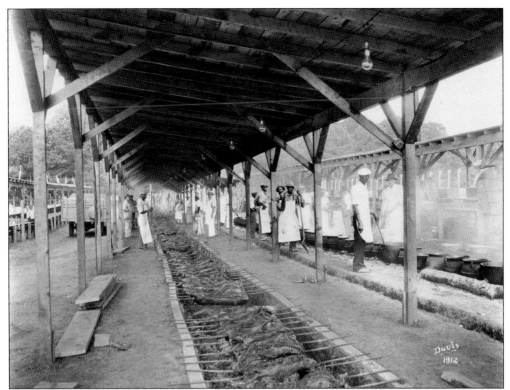

Following the death of Fuller Callaway Sr. in 1928, Callaway Mills began hosting annual picnics to observe his July 15 birthday. The day became a company-wide holiday. These cooks in Manchester worked all night preparing the whole-hog barbeque and the huge kettles of Brunswick stew. The hogs on giant spits had to be turned frequently. The entire town of Manchester had reason to celebrate, because Callaway founded Manchester Mills in 1909 and helped the town come into existence.

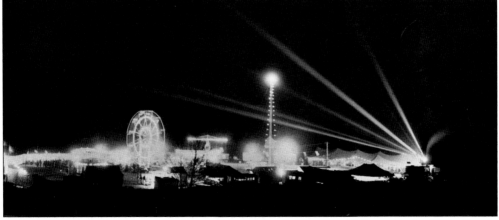

A traveling carnival set up at the fairgrounds off North Greenwood Street in the 1930s. People eagerly anticipated the rides, games, fortune telling, food, and fun. Bright lights helped attract crowds. County fairs often coincided with the carnivals. Locals entered competitions for homemade goods and best breed of various animal categories. In 1948, Col. B.J. Beech developed these lands for housing for World War II veterans and their families. Beechwood Circle remains a popular place to live. (Courtesy of Georgia Archives, Vanishing Georgia Collection, TRP-222.)

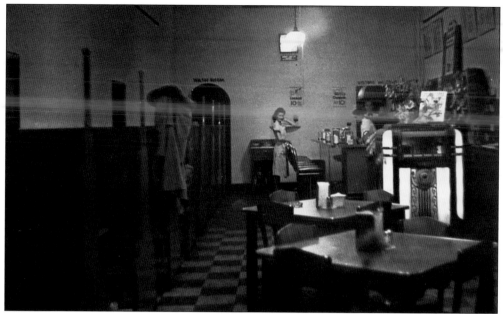

Employees stand ready to serve customers in the mid-1940s at the Tasty Coffee Shop with its elaborate jukebox. "Tasty" had locations on Main Street and South Court Square. Restaurants and inns have long been important businesses in the area. Early inns contained taverns that served travelers and local residents. The large hotels that came along with the railroads starting in the 1850s included formal dining rooms that were often the sites of civic events.

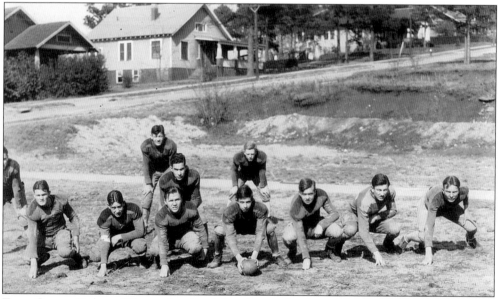

Troup County Parks and Recreation, local churches, and industrial leagues provide opportunities to play football and other sports for young children up to adults. Here, LaGrange High players posed on their practice field near Highland Avenue behind the main school building in the mid-1930s. LaGrange has been home to many football champions through the years, from textile bowl championships for young boys to state and national winners for high school and a division championship for LaGrange College.

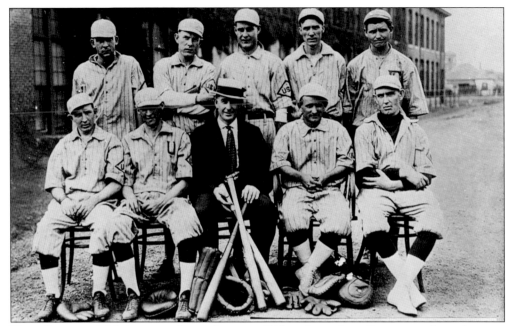

Unity Spinning fielded a team of nine players in 1915, as shown here. Seven years later, the team went undefeated and won the Twilight League with 11 players. Local textile plants sponsored the league. Unity Spinning opened in 1909 on Austin Street. It originally spun twine and yarn. It supplied the yarn for weaving at Unity Mill, later known as Kex. Sam Austin, for whom Austin Street is named, served as one of the original superintendents.

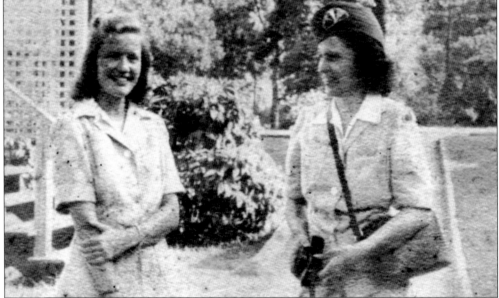

LaGrange College graduates Libba Cunningham (left) and Marjorie Turner reunited during World War II when stationed at Fort McPherson in Atlanta. Libba, who previously worked at the Bell Bomber Plant, acted as hostess of the Service Club, where Marjorie worked as the librarian. After the war, both women married and returned to LaGrange to live. Libba married Henderson Traylor, and "Mardrie" wed Dr. William Fackler Jr. Both have been active in the community for over 50 years.

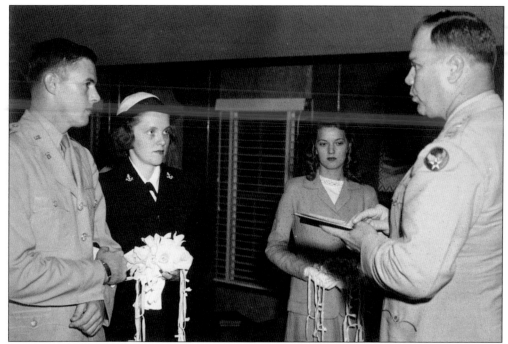

Wearing her Navy WAVE uniform, Memory Sutherland married Forrest Johnson Jr., a member of the Army Air Corps. He was an eighth-generation resident of LaGrange, and she graduated from LaGrange College. Matron of Honor Lee Kamaro observed as Chaplain John Early conducted the October 1944 wedding. The bride got leave from her station in New York to travel to Homestead Army Air Base in Florida. After a brief honeymoon, they did not see each other for almost a year.

Brothers Howard and Reuben Shuford served as sergeants in the US Army during World War II. In those years, families often had more than one member in service. Both men returned from the war, as did another brother, Dexter, from the Army Air Corps. Howard and Dexter then devoted their careers to promoting an enjoyment of sports for area children and adults. In 2000, Troup County Parks and Recreation named Shuford Fields Softball Complex in their honor.

The game of checkers appeals to people of all ages, thanks to simple rules and the need for strategy. Georgia State Checkers Champion Grady Traylor of LaGrange (right) plays at Dallis Street Community Center in June 1949. In another match, Traylor lost six of 10 games to Southern Champion Basil Chase. In days gone by, merchants often had a checkerboard set up at their stores for friendly competitions.

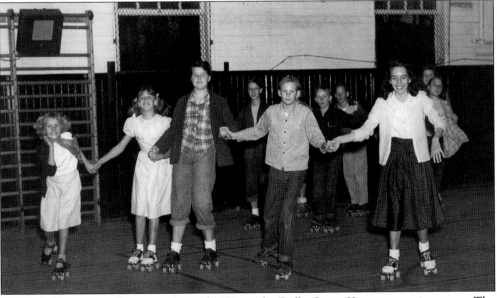

These children enjoy skating in the mid-1950s at the Dallis Street Y or community center. The facility offered basketball, gymnastics, dance, kindergarten, and classes. Callaway Mills built Southwest LaGrange YMCA in 1918 and replaced it with Callaway Educational Association in 1964. Skating as a popular recreational activity dates back to 1881 in LaGrange. Godfred Kener opened a rink in Kener Hall, an early events facility. Ladies skated for free, while gentlemen paid 25¢. Skating remains popular.

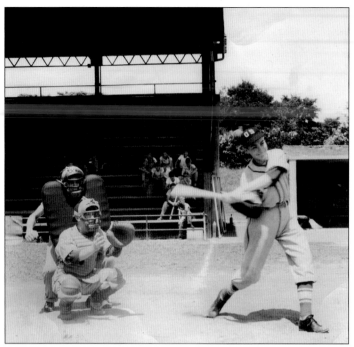

Each local textile plant sponsored baseball teams, as workers and their families participated in America's favorite pastime. The various teams competed with each other and with teams from neighboring towns. The young man at bat represents the Oak-Spinning team from Callaway's Oakleaf and Unity Spinning Mills. Callaway Mills built Callaway Stadium as home field for their many teams. They replaced the structure with a football stadium in 1959.

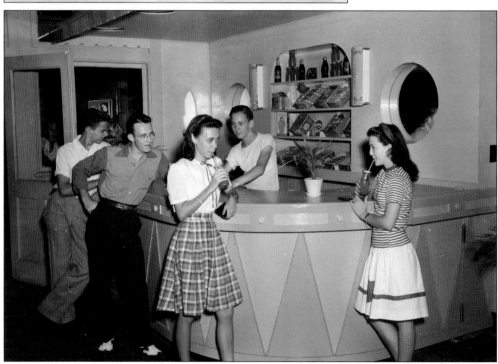

Teenagers found many things attractive about the Dallis Street Y. They especially enjoyed gathering at the snack bar, as this group is doing in 1946. That same year, Callaway Foundation built the Callaway Recreation Center pool for $94,000. Nine years later, it added a soda fountain, bathhouses, dressing rooms, and a grill. In 1994, LaGrange College completed a major renovation of the facility, including renaming it the Charles D. Hudson Natatorium.

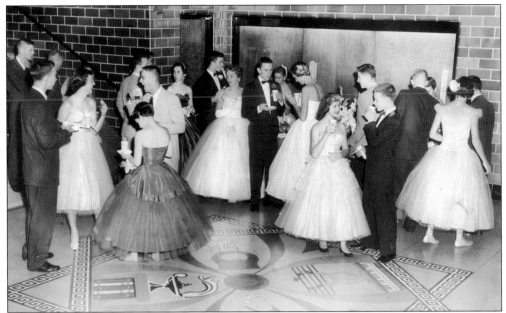

Built in 1941, Callaway Auditorium on Dallis Street has been the scene of many events. The beautiful mosaic in the floor above symbolizes the varied purposes for which the auditorium was built: music, sports, drama, and education. These young people take a break during their Christmas dance in the 1950s to enjoy refreshments in the lobby. Below, school students and adults may have gathered for a band concert. A basketball goal, visible along the right wall and the stage in the background, indicates some other uses of the building. In 1992, Callaway Foundation gave LaGrange College the building. In 2005, the college, with foundation support, completed a major renovation of the interior while leaving the terrazzo floor intact.

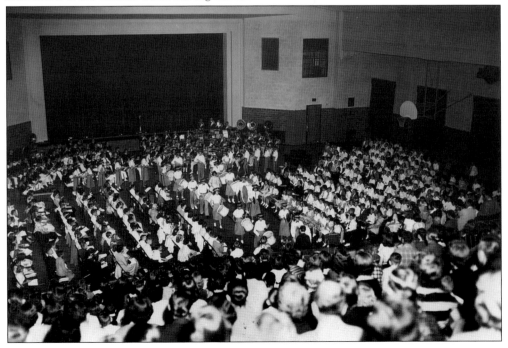

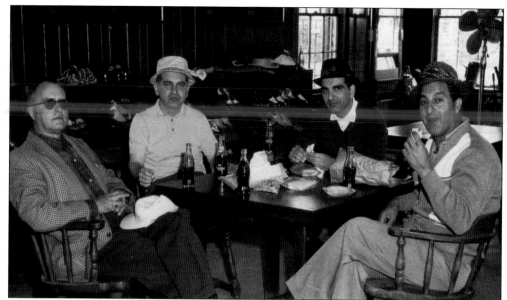

LaGrange residents frequently welcome celebrities. Television comedian Danny Thomas (right) played golf at Highland Country Club with friends Alfred (second from left) and Nasor Mansour (second from right) and club pro Marvin McClain in April 1961. Judge Pete Morgan (left) joined them at the clubhouse for lunch. The star and his wife spent four days in Georgia and attended mass at Saint Peter's Catholic Church. The Mansours became friends with Thomas when they helped raise funds to build Saint Jude Hospital in Memphis.

Some LaGrange College fraternity and sorority events require more secrecy than others. These students have clearly not outgrown their desire to build their own clubhouse. The purpose of this 1959 gathering remains a mystery. Uniformed guards surround the group in the circle. The stylized fish—a Christian symbol—hanging on the clubhouse and a pickaxe stuck in the ground add to the puzzle.

Company picnics serve as a way for employers to show their appreciation to workers, associates, and their families. Here, West Georgia Medical Center hosted a picnic in 1985 on the grounds of the old Jabaley home adjoining the hospital on the east. Hospice LaGrange, part of the medical center, now sits on that site. Construction of a major expansion can be seen in the background. George Kish, longtime assistant administrator, has just been served his meal.

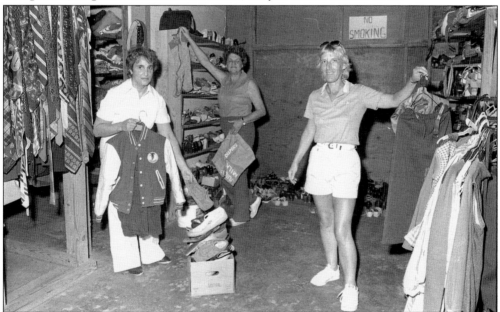

LaGrange has always benefitted from people who give up their leisure time to help others. The LaGrange Council of Church Women opened a center to collect and distribute clothing to needy area residents. It has operated the center from September to May for over 60 years. Women from area churches and LaGrange College students operate the facility, now located on Ridley Avenue. Yolanda Jabaley, the coordinator (left), and others arrange clothing in 1983 at the original West Depot Street location.

From 1993 to 1996, LaGrange hosted over 400 athletes from more than 40 countries. The "I Train in LaGrange" program provided housing, meals, community contacts, practice venues, and other things as needs arose. The city and LaGrange College opened their arms and "adopted" these athletes. Miss Universe Michelle McLean of Namibia, in Africa, came in 1993 and met athletes, including some from her home country, and students at Gardner Newman Middle School.

Numerous agencies and organizations exist to promote literacy in LaGrange, a town historically devoted to education. People of all ages from young to old can find assistance and encouragement in learning to read. Other local organizations exist to promote better care of animals. With his glasses and book, Erk Minchew, named for the famous Georgia Southern and Georgia football coach, urges everyone to read and be good to their pets.

114

Nine

LANDMARKS

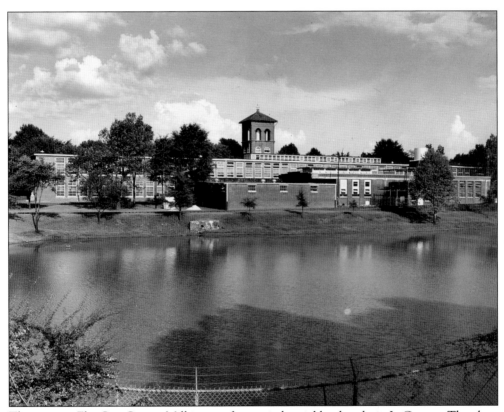

The tower at Elm City Cotton Mill is one of many industrial landmarks in LaGrange. The plant opened in 1905 as part of the Truitt-Callaway group of mills. Located on Elm Street south of Callaway Stadium, the mill originally produced cotton duck fabric. The mill took its name from the town's nickname, "City of Elms and Roses." Deering-Milliken bought the plant and other Callaway Mills in 1968. Elm City ceased production in 2008 after 103 years of manufacturing.

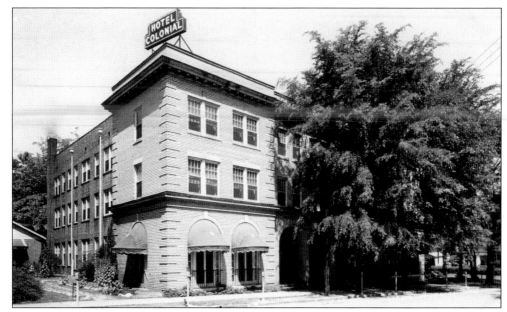

Atlanta architects Ivey and Crook designed the Hotel Colonial, which LaGrange Lumber and Supply Company built in 1922. Sisters Anna, Ethel, and Lois Young built the hotel onto the front of their house, parts of which can still be seen from Church and Haralson Streets. Evidence suggests that the house served as a Confederate hospital during the Civil War. The last of LaGrange's grand hotels closed in the early 1970s. Businesses now occupy this building.

LaGrange City Hall opened on Ridley Avenue in 1926 and continues to serve the people of LaGrange. The yellow brick building features many beautiful Classical architectural details. Atlanta architect Otis Clay Poundstone designed this and the Coca-Cola building on Broad Street. Local contractor Henry Caldwell, who served in the Georgia House of Representatives and Georgia Senate, walks down the steps. In 1970, LaGrange Academy opened in his family home and grounds, which were donated by his daughter.

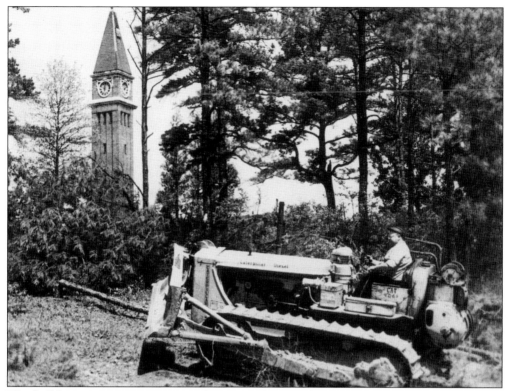

This bulldozer operator removes trees from around one of the oldest and most famous landmarks in LaGrange. Dedicated on July 15, 1929, Callaway Memorial Tower stands on the highest point in southwest LaGrange. Atlanta architects Ivey and Crook designed the clock tower, which is patterned after the campanile of Saint Mark's Basilica in Venice, Italy. Noted landscape architect E.S. Draper designed the surrounding park. The tower is a memorial to Fuller E. Callaway Sr.

Constructed by the US Army Corps of Engineers, West Point Lake officially opened in 1975. Waters extend from the dam just north of West Point to LaGrange and beyond. The lake covers land in both Georgia and Alabama. Many LaGrange residents, some with homes located along the shorelines, enjoy boating, swimming, fishing, camping, and picnicking at the lake. Parks provide venues for tournaments, fundraising events, concerts, and fireworks for special occasions.

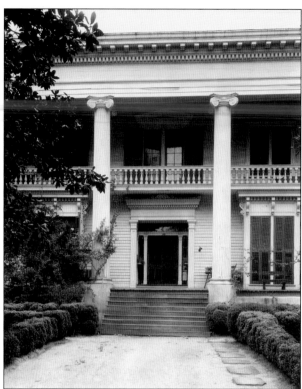

The National Park Service designated Bellevue a National Historic Landmark. Local attorney Benjamin Harvey Hill built this house between 1854 and 1856. He went on to become a Confederate and US senator. Frances Benjamin Johnston made this photograph in 1939 as part of the Historic American Building Survey. Three years later, the Fuller E. Callaway Foundation purchased the house and gave it to the LaGrange Woman's Club. The club operates Bellevue as a house museum.

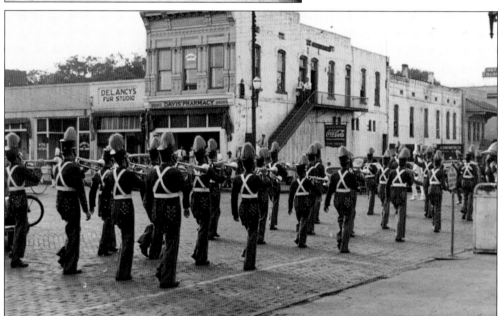

A band marches north from Court Square to Ridley Avenue in the 1930s. George Elbert Dallis built this two-story Victorian commercial structure on the corner in 1893. The building is best known for housing Davis Pharmacy for almost seven decades, although ownership of the building has remained in the Dallis family. Delancy Fur Studio operated from 1939 until the end of World War II in 1945. (Photograph by Stanley Hutchinson.)

In 2009, LaGrange College erected one of the city's newest and most popular landmarks. The bridge provides pedestrian access over busy Vernon Street and US 29 between the main campus and its largest parking area. The clock tower houses an elevator. The board of trustees officially named this the Gulley Gateway in honor of departing president Stuart Gulley and his wife, Kathleen, who wave as they cross the span. Gulley served as president for 13 years.

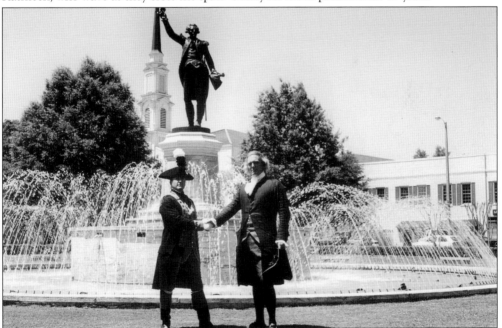

In 2001, longtime friends the Marquis de Lafayette and Thomas Jefferson "came to life" in downtown LaGrange. Represented by actors from Williamsburg, the figures participated in the months-long rededication activities of the Lafayette statue. The monument honors the French hero of the American Revolution. Dr. Waights Henry Jr. conceived the idea to acquire this replica of a statue in LePuy, France, and Callaway Foundation funded the project. LaGrange College placed the statue on permanent loan to the city in 1976.

Clustered together in cemeteries, monuments and memorials become important places in their communities. This unusual obelisk includes a cross and several shields in relief and stands in East View Cemetery in the Dunson Mill area. The city created East View in 1895 for black citizens. Graves of blacks buried in Hill View were moved to this location. Today, some of the town's noted leaders have their final resting place here, including Kings, Kelleys, Browns, and Morgans.

Local citizens chartered the Troup County Historical Society in 1972 to preserve and encourage a greater understanding and appreciation of the history of the county. Legacy Museum on Main, shown here at night, opened at the old LaGrange National Bank Building at 136 Main Street in November 2008. The "Wheels of Change" permanent exhibit has received national and state awards. Now on the second floor, the Troup County Archives has occupied this landmark since 1983.

When surveyed about favorite LaGrange landmarks, numerous people ranked Charlie Joseph's near the top of their list. Founded on Main Street by its namesake, the restaurant has served hotdogs, hamburgers, and sandwiches since 1920. Joseph emigrated from Lebanon and became a US citizen through military service in World War I. Five generations of the family have operated this popular eatery, which moved to Bull Street in 1946 and opened a branch on West Point Road in 1992.

A cluster of landmarks occupies the land around the intersections of Morgan, Broome, and Main Streets. The oldest, Taste of Lemon at left, dates to 1892 as Saint John's Church. The dome and cupola of LaGrange Cinemas 10 stands just beyond the communication tower of WLAG, the oldest radio station in LaGrange. At right is part of the 2006 parking deck, which serves customers and employees of the theater and other downtown businesses.

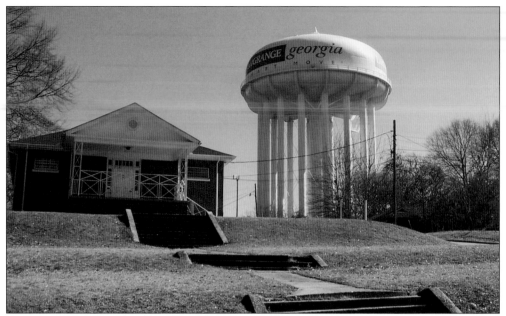

Landmarks can be parks, trees, towers, buildings, and statues. LaGrange maintains several water towers to ensure an adequate supply of water. One of the largest of the towers stands atop a hill that has been known as Freedman's Hill, Standpipe Hill, and most recently Tower Hill. Maidee Smith Nursery, which serves preschool children, sits to the left. The motto "LaGrange Georgia: Smart Move" replaced the old logo adopted in 1974, a coat of arms.

The Troup County government occupies several buildings in LaGrange, including the two courthouse buildings on Ridley Avenue. The authors of this book, Glenda Major (left), Clark Johnson, and Kaye Minchew walk from the 2005 government center toward the 1939 courthouse, now used for juvenile court. A marker honoring Gov. George Michael Troup, for whom the county is named, stands in the foreground. A Vietnam War monument, at right, reminds citizens of the larger war memorial nearby.

This landmark mural overlooks Lafayette Plaza on the south side of Lafayette Square. The artist, Wes Hardin, depicted historic scenes from downtown in his 2007 painting. Citizens portrayed in period costumes are all local people except for Pres. Franklin Roosevelt, who vacationed nearby. The Troup County Courthouse, which stood in the square from 1904 until 1936, is spotlighted. The wrought-iron porch framing this scene leads into the LaGrange–Troup County Chamber of Commerce, which also houses the development authority.

Explorations in Antiquity Center opened in LaGrange off Lukken Industrial Drive in 2006 and has expanded. Its mission is to provide a Biblical world experience. The museum features different scenes from the life of Christ, including this one of the burial cave with the stone rolled aside. A typical first-century meal served in a period-style room is available for groups. The center is modeled after a similar one in Jerusalem.

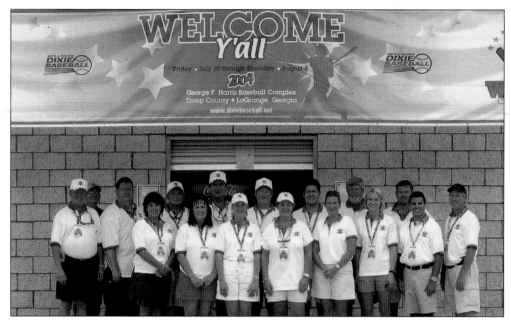

Several sports venues in LaGrange can be considered landmarks, including Shuford Fields, Granger Park, and the William Griggs Center. The planning committee for the 2004 Dixie Boys World Series gathered at the concession stand of the George Harris Baseball Complex. Such events bring in hundreds of thousands of dollars. When not attracting large tournaments, local teams use the facilities maintained by Troup County Parks and Recreation.

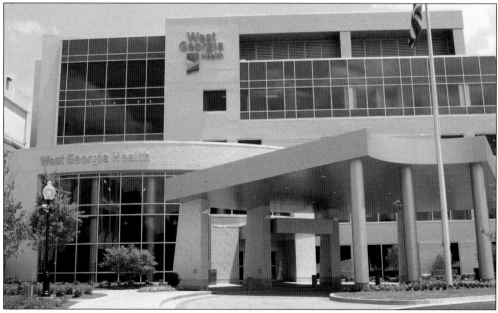

West Georgia Health opened a new entrance in May 2010 when it dedicated the South Tower, a $70-million construction project. The hospital has been a landmark at this Vernon Road location since 1937. As the regional hub for medical care in West Georgia and East Alabama, the hospital offers a wide variety of services and specialty clinics. LaGrange has had a public health service since 1916, when Dunson Hospital opened on Church Street.

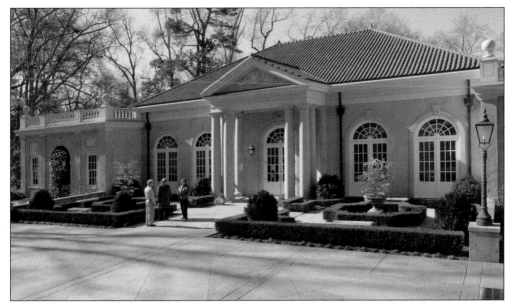

The visitors center at Hills and Dales Estate joins the historic house and gardens as part of a larger landmark off Broad Street. Designed by Cole and Cole of Montgomery and built by Daniel Construction of LaGrange, the center opened October 4, 2004, to serve as an entrance to the estate and an events venue. Neel Reid designed the 1916 Italian villa for Fuller and Ida Callaway. The surrounding gardens date to 1832. All are open to the public.

A 2011 Kia Sorento made in Troup County sits near Del'avant, the renovated Kress and McLellan buildings on Main Street. Kia Automotive opened in nearby West Point in 2009 and employed over 2,000 people in 2010. Sewon America and other suppliers are located in LaGrange and Troup and neighboring counties. Main Street and the historic downtown continue to attract visitors with their variety of restaurants, shops, theaters, museums, athletic venues, and churches.

INDEX

Alford, 16, 31
Allen, Jarvis, 57
Avula, Jaiwant, 98
Awtrey, Phillip and Ada Mendenhall, 100
Bates, Sylvanus, 33
Battle, Andrews, 18
Baxter, Charlene, 14
Beall, Martha Heard, 31
Biagi, Antoinette, 77
Boddie, Nathan Van family, 34
Bonner, John, 57
Boy Scouts of America, 37
Boyd, James and Annette, 74
Burdette, Debbie, 58
Business, 47, 55, 62, 63, 84, 87, 91, 96, 97, 106, 116, 121
Caldwell, Henry, 116
Callaway, 7–8, 12, 50, 52–54, 59, 60, 62, 64, 65, 67, 69, 71, 74, 78, 82, 88, 96, 105, 109–111, 115, 117
Callaway family, 3, 64, 70, 83, 92, 95, 104
Carter, Jimmy, 97
Cemeteries, 19, 25, 27, 120
Chattahoochee River, 13
Churches, 32, 35–46, 59, 78
Cleaveland, 84, 93
Colleges, 12–14, 19, 29, 31, 48, 49, 51, 52, 58, 59, 69, 72, 74, 75, 77, 78, 94, 99, 111, 112, 119
Colquitt, John, 20
Copeland family, 75, 97
Cox, Mary Dortch Pitman, 18
Crews, Walter, 52
Culpepper, Sally Lane, 103
Curtright, Barbara Howell and Samuel, 22
Dallis family, 7, 51, 118
Dansby, William, 33
DASH, 36

Del'avant, 85, 125
Dixie Community Center, 64
Dodd, Lamar, 70
Dunson, 7, 36, 90–91, 120, 124
Dyar, Julia Traylor, 15
Easley, Curran, Sr., 65
Edmondson, Michael, 56
ESPN, 60
Estes, Max and Martha, 72
Evans, 20, 89
Explorations in Antiquities, 123
Fackler, Mardrie Turner, 107
Ferrell Gardens, 28, 29, 83
Ferrell family, 17, 28, 36
Frost, Francis, 33
Fuller, Willie, 90
Glanton, Samuel P. and Harriett, 99
Greene family, 20, 29
Greenwood, Thomas Bristow, 23
Gulley family, 60, 119
Harris, 29, 63, 124
Harrison, James W. family, 21
Heard, George B. and Alberta, 32
Hearn, 13
Henry, Mamie Lark, 72
Herring, James, 21
Highland Country Club, 103
Hill, Benjamin Harvey, 31, 118
Hills and Dales Estate, 17, 125
Hillside community, 80
Hine, Lewis, 81
Hipp, Seale, 91
historic houses, 22, 29, 31, 51, 94, 118
Hudson family, 60, 75
Hyde, Joe Glenn, 95
Indians, 9–12, 17
Jabaley, Yolanda, 113

Johnson family, 84, 108, 122
Jones family, 79
Kia Automotive, 46, 125
Knight, Danny, 56
Kress, 85, 125
Lafayette, 63, 77, 119, 123
LaGrange, 48, 52, 60, 65, 70, 76, 77, 87, 93, 113, 116
LaGrange, Oscar Hugh, 26–34
Lewis, 32, 58
Lovejoy, Clyde, 88
Major family, 98, 122
Mallory, 75
Mansour family, 112
Manufacturers, 46, 59, 98, 125
Marchman, Clare, 15
McAlexander, Dan, 60
McLellan, 125
McLendon, Alice Boykin, 31
Merritt, Elizabeth Parks, 19
Miles, Robyn, 60
Mims family, 64
Minchew, 114, 122
Morgan, Pete, 112
Murphy family, 60, 72
O'Neal, Reuben Shirley, 102
orchestra, 68, 78
Order of the Tartan, 78
Phillips, Philip and Eugenia Levy, 32
Pike, 61, 84, 100
Quillian, Lila, 88
Red Cross, 53, 54, 88, 92
Reid, Samuel, 16
Richter, Horace and Dorothy, 41
Ridley, Robert A.T., 18
Rotary Club, 102
Russell, Clifford, 96
Sanders, Vannie, 54, 66
Sargent, Mary Page, 61
Schools, 47–62, 68, 69, 71, 73, 89, 106, 122
Sellers, Ezra, 70
Shuford, Howard and Reuben, 108
Sledge family, 17
Sons of Lafayette Male Choir, 77
Southwest LaGrange Concert Band, 66
Sutherland, 85, 108
Sweet Land of Liberty Parade, 74
Tarver, Nancy, 20
textile mills, 44, 65, 80–82, 96, 107, 115
Thomas, Danny, 112
Thomastown Barbershop, 86
Traylor, 27, 107, 109

Tri-Y Club, 40
Troup County, 16, 24, 56, 75, 78, 122
Truitt family, 7, 19
Tubb, Ernest, 66
Tuggle, William Orrie, 11
Turner, Abner, 19
Tuskegee Airmen, 90
Walker, E.G., 86
West Georgia Medical Center, 98, 113, 124
West Georgia Underwater Archeology, 13
West Point, 26, 29, 117
Whitfield, John Gibson, 23
Wiggins, Jennifer, 14
Williams, 71, 83
Wilson, J.H., 26
Wooding, H.S. and Jennie Lou, 104
Young sisters, 116

www.arcadiapublishing.com

Discover books about the town where you grew up, the cities where your friends and families live, the town where your parents met, or even that retirement spot you've been dreaming about. Our Web site provides history lovers with exclusive deals, advanced notification about new titles, e-mail alerts of author events, and much more.

MADE IN THE USA

Arcadia Publishing, the leading local history publisher in the United States, is committed to making history accessible and meaningful through publishing books that celebrate and preserve the heritage of America's people and places. Consistent with our mission to preserve history on a local level, this book was printed in South Carolina on American-made paper and manufactured entirely in the United States.

This book carries the accredited Forest Stewardship Council (FSC) label and is printed on 100 percent FSC-certified paper. Products carrying the FSC label are independently certified to assure consumers that they come from forests that are managed to meet the social, economic, and ecological needs of present and future generations.

FSC
Mixed Sources
Product group from well-managed forests and other controlled sources

Cert no. SW-COC-001530
www.fsc.org
© 1996 Forest Stewardship Council

Find Your Place in History.